An Edmonton Album

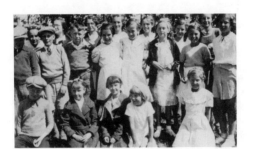

An Edmo

An Edmonton Album
GLIMPSES OF THE WAY WE WERE

JO-ANNE CHRISTENSEN
&
DENNIS SHAPPKA

HOUNSLOW PRESS
A MEMBER OF THE DUNDURN GROUP
TORONTO · OXFORD

Hounslow Press
A Member of the Dundurn Group

Publisher: Anthony Hawke
Editor: Barry Jowett
Design: Scott Reid
Printer: Transcontinental Printing Inc.

Canadian Cataloguing in Publication Data
Christensen, Jo-Anne
An Edmonton album: glimpses of the way we were

ISBN 0-88882-212-X

1. Edmonton (Alta.) — History — Pictorial works. 2. Edmonton (Alta.) — History. I. Shappka, Dennis. II. Title.

FC3696.4.C47 1999 971.23'3 C99-932274-5 F1079.5.E3C47 1999

1 2 3 4 5 03 02 01 00 99

We acknowledge the support of the **Canada Council for the Arts** for our publishing program. We also acknowledge the support of the **Ontario Arts Council**, and we acknowledge the financial support of the Government of Canada through the **Book Publishing Industry Development Program** (BPIDP) for our publishing activities.

Care has been taken to trace the ownership of copyright material used in this book. The author and the publisher welcome any information enabling them to rectify any references or credit in subsequent editions.

Printed and bound in Canada.

Printed on recycled paper.

Hounslow Press	Hounslow Press	Hounslow Press
8 Market Street	73 Lime Walk	2250 Military Road
Suite 200	Headington, Oxford,	Tonawanda NY
Toronto, Ontario, Canada	England	U.S.A 14150
M5E 1M6	OX3 7AD	

For our parents, who helped build this city:

George and Stella Shappka,
and
Pat and Ray Christensen

Acknowledgements

This book would not have come to be without the assistance, suggestions, and encouragement of certain people whose contributions deserve to be acknowledged.

Our appreciation goes first to our publisher, Tony Hawke, for bringing the idea to us.

The helpful and knowledgable staff at the City of Edmonton Archives made the research portion of our job easier than we could have imagined. We thank all of you for being so good at what you do.

And, finally, our sincere gratitude is owed to Barbara Smith; a dear friend who not only helped with the research, but brought the best puffed-wheat squares in the world to fuel the endeavour.

Introduction

In 1982, a college classmate who hailed from Montreal said something that would forever change the way I viewed Western Canada. We were talking about history and she noted that, in comparison to the east, the history out here was all extremely recent. I assumed she meant disinteresting, or shallow, or unimpressive — my prairie inferiority complex was in full flower during my late teens. But, in fact, she went on to explain that she found our heritage fascinating, for one reason in particular.

"Some of the pioneers here are still walking around," she said. "You have the opportunity to get stories about the settlement of this area first-hand."

She saw not a lack of history, but a living history. I began to look at my familiar territory with new appreciation, and I never forgot my friend's comments.

Just last year, I experienced a similar awakening as my husband Dennis and I discovered yet another unique advantage of living on such recently turned soil. Edmonton, incorporated in 1892, is a young city, and as such, its development has been completely documented photographically.

That's significant, because photos provide a historical perspective that words occasionally miss. They capture nuances and seemingly inconsequential details that can be as interesting as the main subject. For example, in the 1914 photo illustrating the breaking news of World War I *(page 139)*, you may note that every man in the crowd is wearing a hat. That visual sidebar is a bit of social history that has nothing directly to do with the Great War, but it gives you just slightly more insight into the daily lives of those who would be so affected by it. And it's precisely the sort of detail that may be missed in a written account.

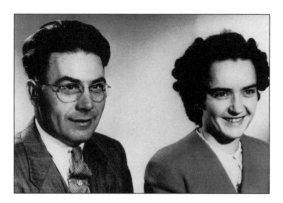

George and Stella Shappka, circa 1947. Courtesy Shappka family private collection.

Cameras also tend to be on hand to record our moments of leisure and whimsy — again, the stuff that tends to get lost in the bigger historical picture. For example, the 1930s-era photos in this book show that the Depression wasn't *all* depressing. People still went trick-or-treating, and boating, and cared about who won the World Series. Certainly there are pictures that capture the desperate ache of poverty, and they are not to be discounted. But the whole truth is made up of many separate realities.

However, the camera is limited in its own fashion. Some landmark events have happened with no photographer in attendance; others have simply not been visual in nature. Conversely, common and insignificant moments are often beautifully recorded. That contradictory nature of film became paramount during the shaping of this book.

At first glance, *An Edmonton Album* appears to be a history book. More accurately, however, it is a nostalgic look at the city's past. It is more your family photo album, filled with memories and highlights, than it is a meticulously researched family tree. And because it *is* a photo album first and foremost, we looked for stories to enhance the pictures, as opposed to the usual method of finding something visual to complement the text.

In finding those photos and those stories, we also rediscovered our affection for this city. A measure of that is simple home-town cheerleading. We feel connected to this place, knowing that our grandparents broke land in the surrounding communities, and that our parents were among those who came to the city to live and work and build up the individual neighbourhoods.

Dennis's father was a veteran of World War II who returned home to marry and build a home in King Edward Park, as did so many during the post-war boom. My own parents bought a home some years later in Mayfield, an area named in honour of Edmonton's famous pilot. The part our families played is one tremendous source of pride, but another is simply that this is a beautiful and vibrant city in which we live. Great people built this place; great dramas unfolded here; and we have what we have because of a frontier spirit that is evident to this day.

The unfortunate thing is, we tend to overlook or underestimate the value of our own history. Most Edmontonians know more about Charles Lindbergh than they do about Wop May; more about Babe Ruth than any of the Edmonton Grads; and more

Introduction

about the bombing of America's Pearl Harbor than the countless heroic battles fought by our own 49th Battalion.

The least problem this creates is that we are left with no appreciation of our own roots. The greatest is that it contributes to the sort of ignorance and lack of reverence that led to historic Walter House being all but destroyed by arsonists during the writing of this book.

Bearing all this in mind, we request two things of you, as you turn the page. First, please simply enjoy the ride. Some of these photos are bound to evoke memories — no matter what your age. Both Dennis and I were born after the mid-fifties, which is when we end this retrospective, but many of the images we found reminded us of family photos or stories, while others gave us a fresh appreciation for the city landmarks and neighbourhoods we've known all our lives.

Our second wish is this: the next time you drive down Groat Road or Walterdale Hill, the next time you pass McCauley Plaza or Clarke Stadium, the next time you visit Emily Murphy Park or cross the Dawson bridge or travel anywhere in this city, stop to wonder who were these people, and acknowledge what they left here along with their names.

After all, it is people who make up a city, and Edmonton has been home, truly, to some of the best.

Jo-Anne Christensen
Edmonton
June 28, 1999

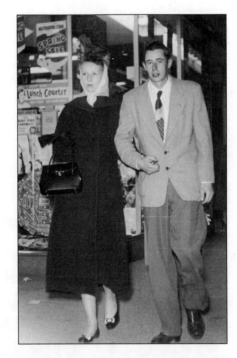

Pat and Ray Christensen, captured by an Edmonton street photographer in the mid-1950s. Courtesy Christensen family private collection.

The original Fort Edmonton was built by the Hudson's Bay Company in 1795, near present-day Fort Saskatchewan. The outpost was relocated four times in as many decades, however, before settling in 1830 upon the ideal site: near what would become Alberta's Legislative grounds.

The fort, established as a fur-trading post, was part of the Hudson's Bay Company's westward expansion in an effort to compete with the rival North West Company. It proved to be a strategic trading position, and a natural distribution centre for the western prairies.

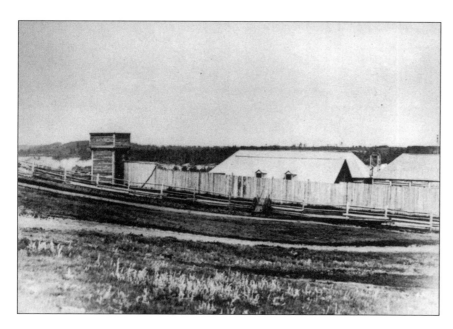

Fort Edmonton, circa 1871.
City of Edmonton Archives (COEA) EA-267-455.

When Fort Edmonton was first established as a trading centre, traditional currency had no place in the west. The barter system was used in all transactions, with fur being the favoured medium of exchange.

The value of goods was determined in "made-beaver" pelts. A good horse was worth twenty made-beaver; a large axe was worth four. One made-beaver would get you any of the following: eight buffalo tongues, one and one-half feet of Canadian roll tobacco, one hundred pounds of grease, a scalping knife, ten balls of ammunition, or one quarter-pound of gunpowder.

Fur traders, circa 1900.
COEA EA-9-318.

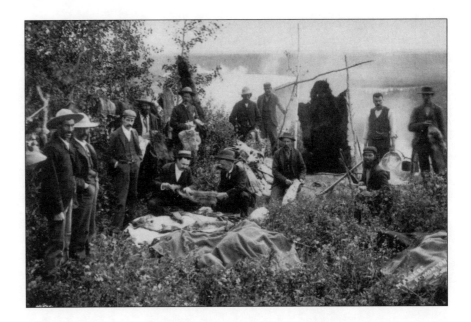

These were the boats sent out from York Factory by the Hudson's Bay Company; each one carrying up to five tons of goods that could be traded to the Natives for furs and buffalo meat. York boats could be sailed when the wind was favourable, or rowed when it was not. Occasionally, the boats were "tracked," or, literally, towed upstream by men walking along the shore.

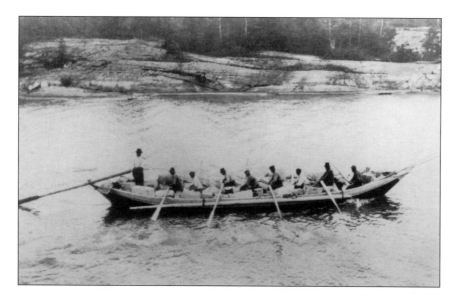

York boat on the North Saskatchewan River, circa 1900.
COEA EA-112-12.

The notice ran in the *Edmonton Bulletin*:

> *Those having children of school age please remember that school will open precisely at 9 o'clock*
> *on Tuesday morning next, under the supervision of Mr. J. Harris. Terms — nothing. Books, slates,*
> *etc. should be got in readiness beforehand.*

On January 3, 1882, Edmonton's first schoolhouse opened to an enrollment of twenty-five boys and three girls. The rough frame building had been constructed at a cost of $968, solicited from members of the community. An additional $500 was raised to pay the teacher. Still, supplies were few and comforts were fewer, and Edmonton's first school had a rocky start.

James Harris, the teacher, died within a few weeks, and two replacements had to be found before the term was through. The Hudson's Bay Company reclaimed the iron box stove, and freezing students were sent home until another could be found. Classes also had to be cancelled on the occasions when district court was held in the schoolhouse.

In that first rough semester, students studied reading, writing, arithmetic, geography, dictation, spelling, history, and grammar. And though certain hardships had to be endured, Edmonton's one-room schoolhouse served its purpose.

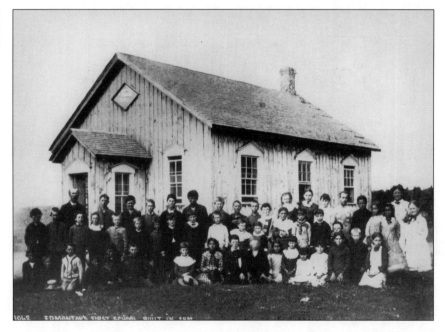

Edmonton's first school, circa 1890.
COEA EA-10-909.

13

In 1904, on the site of Edmonton's original schoolhouse, McKay Avenue School was built. The eight-room brick and stone structure bears the name of a Hudson's Bay Company surgeon, Dr. William Morrison MacKay, although it will forever be misspelled "McKay" on the carved sandstone tablet above the doors.

McKay Avenue school carries the distinction of having housed the first two sessions of the Provincial Parliament. It has also seen a number of students move on to fame and fortune, including Supreme Court Justice Ronald Martland, actor Leslie Nielsen, and Clarence Campbell of the National Hockey League.

Today, McKay Avenue School has been restored, and is used as an educational archives and museum.

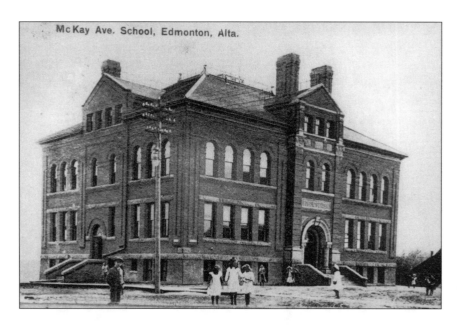

McKay Avenue School.
COEA EA-10-868.

As Edmonton grew from a northern trading post to a modern city, brick was one of the popular and practical building materials. A Scottish businessman named James B. Little recognized the growing need and, with a single horse-powered machine and ten acres purchased on the Riverdale Flats in 1892, established a successful brickyard.

Business boomed and, within a decade, Little required an additional twenty acres and numerous mechanical upgrades to keep up with demand.

J. B. Little's Brickyard.
COEA EA-47-01.

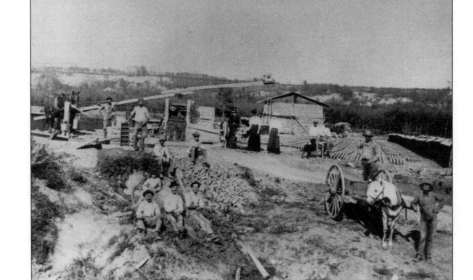

When six members of the North West Mounted Police posed outside a log cabin for this photo, it had been only eleven years since the first detachment of twenty Mounties reached Fort Edmonton.

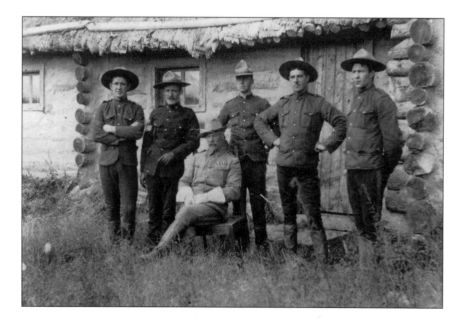

North West Mounted Police, circa 1885.
COEA EA-10-871.

A coal car exits the Donald Ross Tunnel, November 6, 1891.
COEA EA-10-1180.

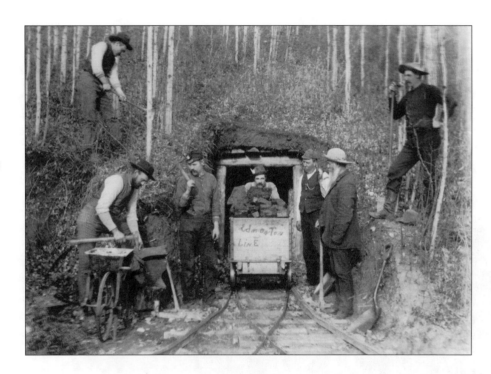

E dmonton's early settlers found all the coal they needed by digging small "gopher-holes" in the riverbank. By the 1880s, however, with the introduction of steam boats, saw mills, and other fuel-eating machines, increasing coal consumption gave birth to a true industry. Mining remained part of the economy for nearly a century, and an estimated fifteen million tons of the black rock was taken from beneath the city.

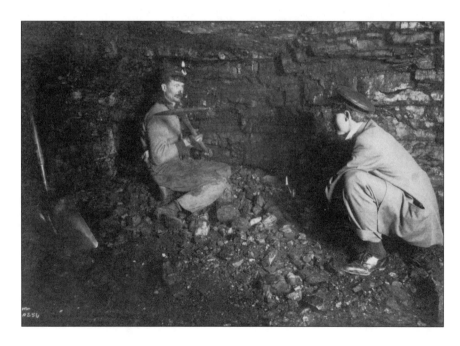

Coal mine interior, circa 1907.
COEA EA-500-91.

Workers at the Bush Coal Mine, 1937.
COEA EA-160-1490.

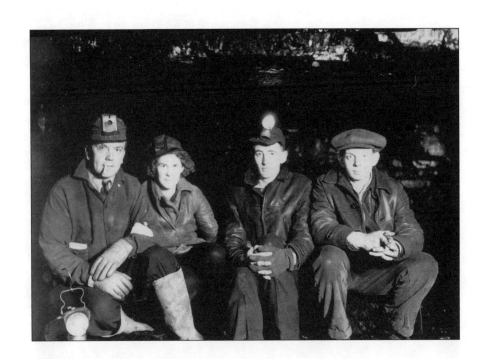

In the early days, Edmontonians who needed to be hospitalized were taken to St. Albert, where the Institute of the Sisters of Charity of Montreal ran a facility. The Sisters, better known as the Grey Nuns, were eventually persuaded to build a hospital in Edmonton. That hospital would be the General Hospital, which was officially consecrated on August 15, 1895. On August 16, 1895, it received its first patient.

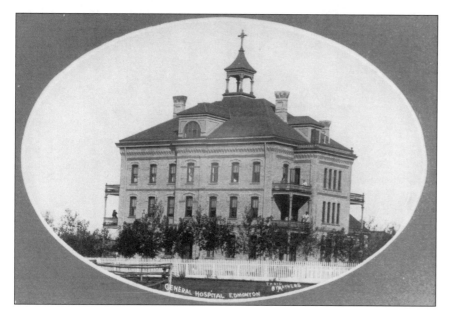

General Hospital, circa 1900.
COEA EA-10-867.

Edmonton baseball team, 1890.
COEA EA-10-16.

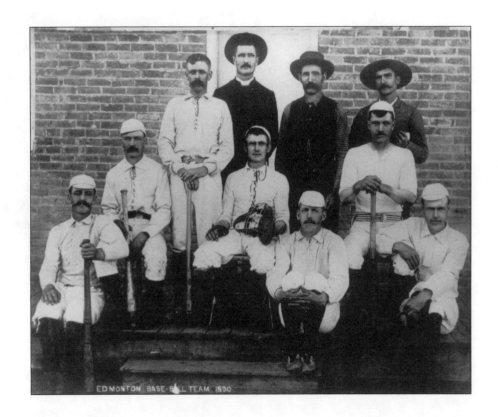

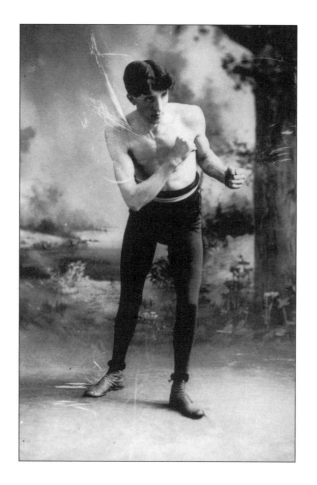

Kid Lavigne, boxer.
COEA EA-124-5.

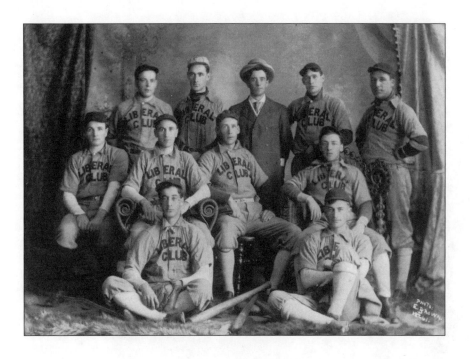

The Liberal Club Baseball Team, circa 1900.
COEA EA-10-20.

One of the winning curling rinks from the 1904–05 season, posing with a number of trophies. Note the corn brooms used in the sport at that time.

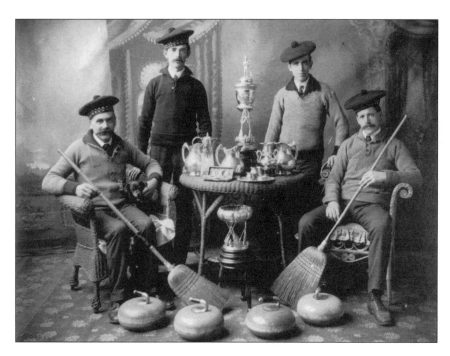

Edmonton curlers, 1905.
COEA EA-398-5.

In the early 1890s, gold dredges came into use as a means of mining the submerged portions of the bars. In 1898, there were twelve dredges operating on the North Saskatchewan; but by 1907, low profit margins and the lure of the Klondike had reduced that number to one.

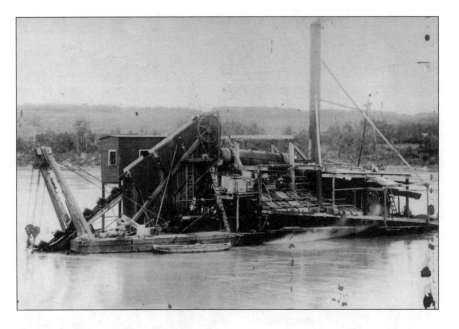

Gold dredge on the North Saskatchewan River, circa 1900.
COEA EA-17-8.

The five miners panning for gold in this photo may have recovered something but, the fact is, at this point, Edmonton's gold rush had been over for a number of years.

Gold mining peaked in the Edmonton area between 1895 and 1907. The first two of those years saw the highest yield from the North Saskatchewan River, with a total of 7,500 troy ounces of gold produced. By 1898, the Klondike Gold Rush was drawing most miners away from Edmonton, although small-scale operations continued along the river valley for decades.

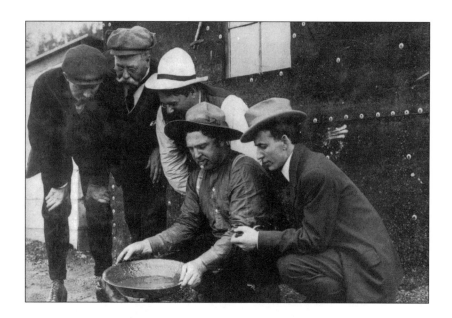

Gold panning, circa 1914.
COEA EB-23-59.

26

John Walter was born in the Orkney Islands, and came to Edmonton in 1870 as a boat builder for the Hudson's Bay Company. When his five-year arrangement with the HBC had been fulfilled, Walter set out on his own, convinced he could do better as an independent businessman. He was right.

For Walter's first thirty years in business, he was a seemingly unstoppable success. He built boats, ferries, and carriages. He came to own two huge lumber mills and a coal mine. His investments included numerous properties, and "Walter's Ferry," the first means of transit across the North Saskatchewan. He played at politics, and was associated with a number of good causes, and Edmonton "firsts."

His luck seemed to sour, however, beginning in 1907, with the mine disaster that killed six of his employees. In 1913, the completion of the High Level Bridge made Walter's Ferry obsolete, and the 1915 flood of the river flats destroyed his mills and cost him hundreds of thousands of dollars — a financial loss from which he never completely recovered.

John Walter died on Christmas Day, 1920, fifty years nearly to the day after his arrival in Edmonton.

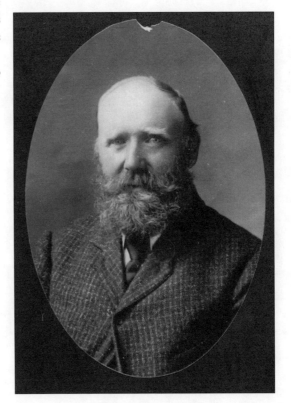

John Walter, 1904.
COEA EA-10-669.20.

27

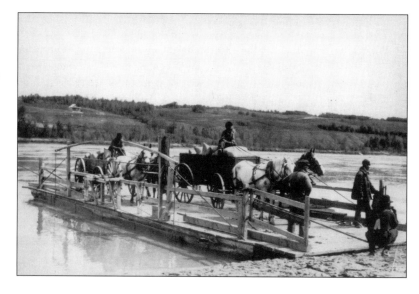

John Walter's Ferry, the *Belle of Edmonton*, circa 1900.
COEA EA-10-2810.

J ohn Walter's Ferry operated for twenty years on the North Saskatchewan River, at the point where the High Level Bridge would eventually be built. It was the first cable ferry in Alberta.

Poster, COEA — John Walter subject file.

28

Official opening of the Low Level Bridge, 1900.
COEA EA-10-295.

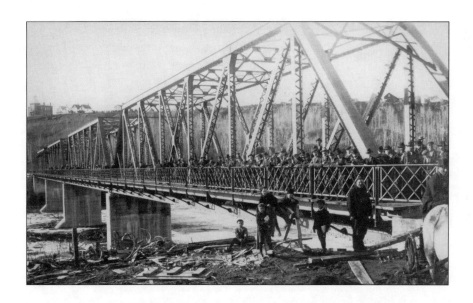

The Thistle Rink — a huge barn of a building on 102 Street, just north of Jasper Avenue — became an integral part of Edmonton's history within the span of one short decade.

Memories of the Thistle were vivid and varied. The rink hosted hockey games so riotous the fans were literally "caged" behind wire screens in an effort to protect the players. There were exhibitions, rallies, and spectacular theatrical and social functions attended by the elite. As the largest closed building in Edmonton, it was chosen to hold Alberta's very first Legislative Assembly, as well as the new province's inaugural ball.

The Thistle Rink's history was colourful, and it was brief. Early in the morning of October 31, 1913, the building was destroyed in a raging fire. The armoury of the 101st Regiment Edmonton Fusiliers was housed in the rink, and at the height of the blaze, twenty thousand rounds of ammunition discharged. The crowd of spectators may have seen it as a fittingly dramatic farewell salute to a building that served the city so well.

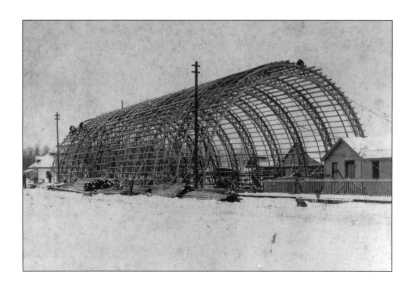

Thistle Rink under construction, 1901.
COEA EA-430-2.

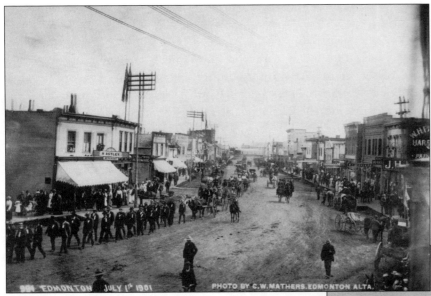

Jasper Avenue, looking east, 1901.
COEA EA-10-180.

Jasper Avenue, looking west, 1910.
COEA EA-10-195.

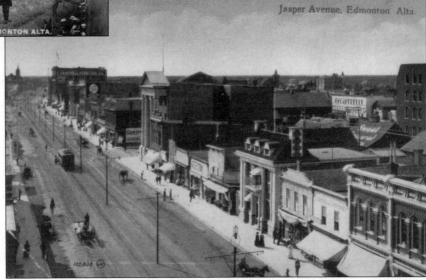

W hen sod was turned for a new railway in July of 1890, Edmontonians reasonably expected to see their first train by the following spring. There was much disappointment when the Calgary and Edmonton Railway established its northern terminus on the opposite side of the river, in South Edmonton (later named Strathcona).

It was, in fact, a dozen years before this historic crossing of the Low Level Bridge could be snapped. The *Edmonton Bulletin* floridly described the event as "the climax and fruition of strenuous exertions and untold hopes and disappointments which had lasted for half a lifetime…"

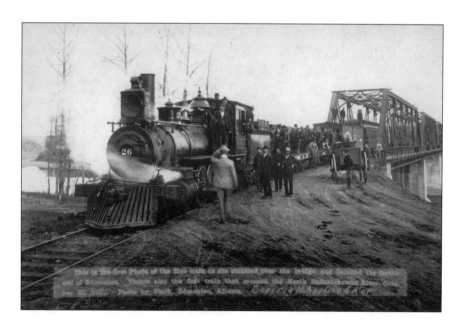

First train across Low Level Bridge, 1902.
COEA EA-430-1.

32

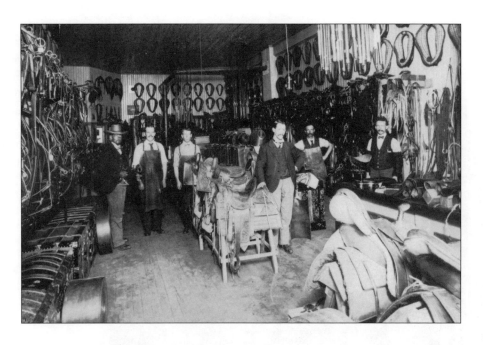

Interior of Great West Saddlery, 1904.
COEA EA-398-4.

It was a birthday to remember — featuring lavish decorations, music, food, and dignitaries. There was a high level of excitement among the thousands of guests; many of whom had travelled a great distance on specially appointed trains. It was September 1, 1905 and, as the new lieutenant governor bent to kiss the Bible, Alberta was born into Confederation.

Though the new province was united in the spirit of festivity, it would almost immediately become bitterly divided over the issue of the permanent capital. Edmonton and Calgary were the main contenders; Calgary's status as an economic hub was pitted against Edmonton's position as a busy northern gateway.

In the end, partisan politics was to be the deciding factor. Alberta's interim premier was Alexander Cameron Rutherford, the leader of the provincial Liberals, who strongly favoured Edmonton. Perhaps even more influential was the federal Minister of the Interior at that time. It was none other than Frank Oliver; the publisher of the *Bulletin* who had been an outspoken Edmonton booster for more than twenty-five years.

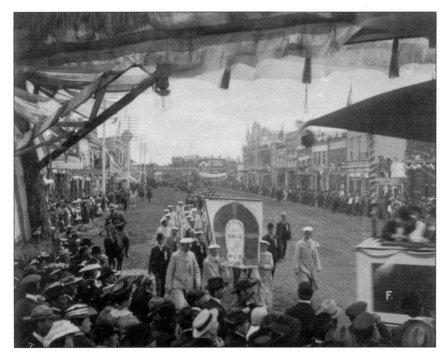

Inauguration parade on Jasper Avenue, September 1, 1905.
COEA EA-253-1.

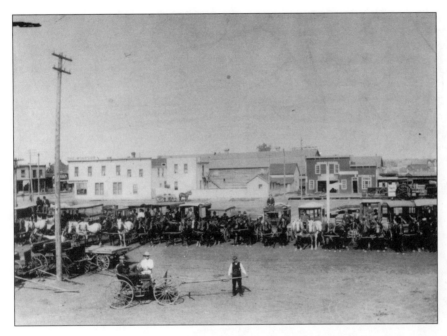

Hotel buses and taxis wait for the train in Strathcona, 1906.
COEA-10-1273.

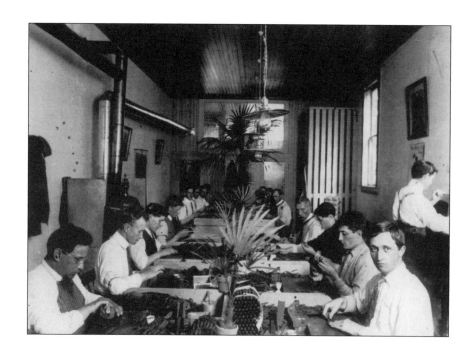

Workers in the Edmonton Cigar Factory, circa 1907.
COEA EA-274-01.

The *Edmonton Bulletin* called it "the worst tragedy in the history of Northern Alberta" and, at that time, it was undoubtedly so. On June 8, 1907, six men died at Walter's mine, part of the Strathcona Coal Company owned jointly by John Walter, William Ross, and Premier Alexander Rutherford.

Five of the miners had been trapped by a fire that broke out at the mouth of the mine shaft. Their foreman, George Lamb, was asleep at home when he heard of the blaze. Heroically, he rushed to the aid of his workers, only to become the sixth victim.

The men were mourned throughout Edmonton and Strathcona, and the *Bulletin* later reported that "never … [had] there been a more impressive spectacle" than attendance at the funeral.

One service was conducted at St. Anthony's Church; the five others, on a makeshift platform in front of Wainright's undertaking parlour, as shown in the photo. This crowd later joined the mourners from St. Anthony's to form a cortege one mile long, as they proceeded to the Strathcona and Catholic cemeteries.

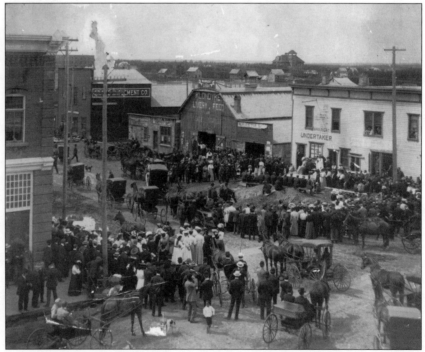

Funeral for coal miners, June 11, 1907.
COEA EA-10-3143.

Edmonton — the city that had no train service until 1902 — had three competing companies by the time this photo was taken: the Canadian Northern Railway, the Canadian Pacific Railway, and the Grand Trunk Pacific Railway.

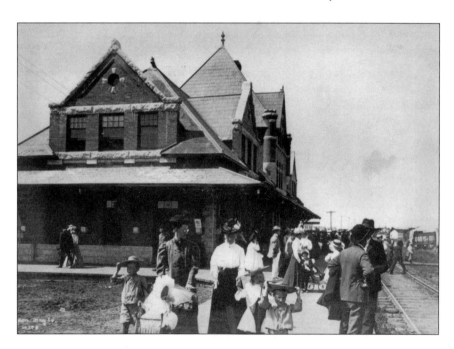

Passengers outside the CNR station, 1907.
COEA EA-500-155.

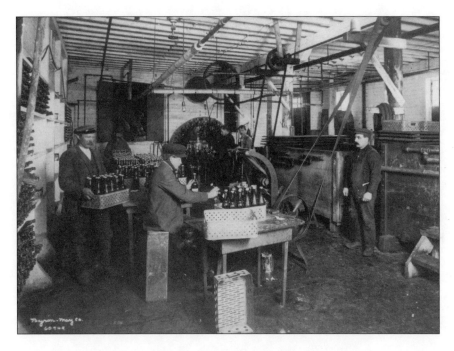

The Edmonton Brewing and Malting Company, 1908.
COEA EA-500-136.

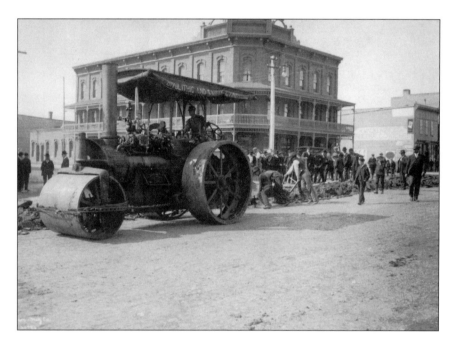

Paving Jasper Avenue, 1908.
COEA EA-500-62.

Joseph Henry Morris was a successful retail businessman who will always be remembered for bringing the first car to Edmonton. It was a Ford automobile he purchased impulsively while in Winnipeg on a business trip. Morris had it shipped west on the same train on which he travelled home.

This was 1904. It would be one year before Alberta joined Confederation, and fully another year after that before the province's new government passed The Automobile Act, requiring operator's licences. By that time, there were an astounding forty-one cars in the province; but Joe Morris — claiming seniority — applied for, and was granted, licence number one.

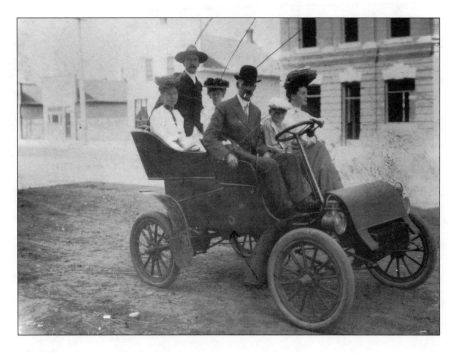

The first car in Edmonton, 1904.
COEA EA-10-2781.

41

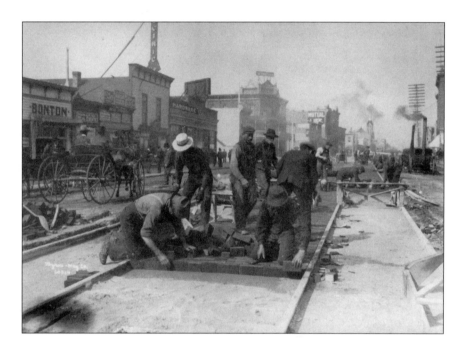

Laying streetcar tracks on Jasper Avenue, 1908.
COEA EA-500-57.

In 1892, Edmonton's first mayor, Matthew McCauley, travelled to Ottawa to obtain a charter for an electric street railway system. More than fifteen years later, in 1908, the Edmonton Radial Railway finally began operations.

People who travelled around Edmonton in its streetcar era can often provide a colourful story or two. Many recall the thrill of riding across the High Level Bridge, the novelty of borrowing a book from the well-lined shelves of the special "library car," or the folksy legends of the McKernan Lake Line, known (owing to a popular comic strip of the time) as the "Toonerville Trolley."

The Lake route existed only because of a concession in the Edmonton-Strathcona Amalgamation Act of 1912. It served a largely unpopulated area, rattling past more than a mile of vacant lots at one point. Never profitable, (in fact, it is estimated that the route cost the city approximately $350,000 in its lifetime), it did, however, provide Edmonton with a wealth of stories. The motormen were famous for their personal brand of service — they would stop to wait for passengers who were still as far as a block away from the car, and often did little errands and deliveries for people along the line. On one occasion, a motorman took the time to rescue a stranded family of ducklings and deliver them safely to the lake.

The McKernan Lake Line, and all others, eventually disappeared to make way for motor and trolley coaches. Streetcar service ended in Edmonton on September 2, 1951.

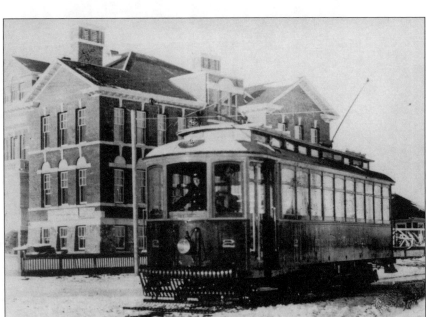

Streetcar #2, 1908.
COEA EA-10-1386. Tickets, COEA MS 188.

The Hudson's Bay Company introduced steamboats to the North Saskatchewan River in the mid 1870s. These large, flat-bottomed vessels replaced York Boats, providing a more efficient means of shipping goods.

Steamers played an important role in several areas of Edmonton's growth. They brought an increase in river trade, which attracted a number of independent businesses, and also triggered development in agriculture and industry, as they made it possible to bring in machinery that would not otherwise have been available to the area.

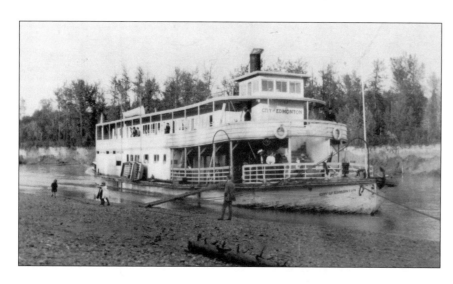

The *City of Edmonton* steamer, June, 1915.
COEA EA-249-7.

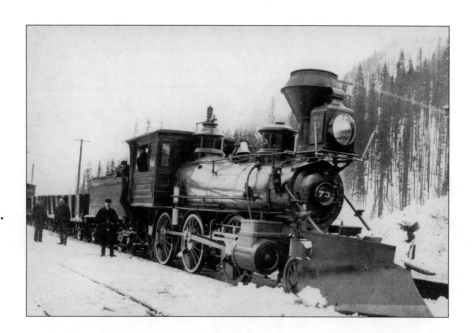

CPR engine #73, 1920.
COEA EA-10-1287.

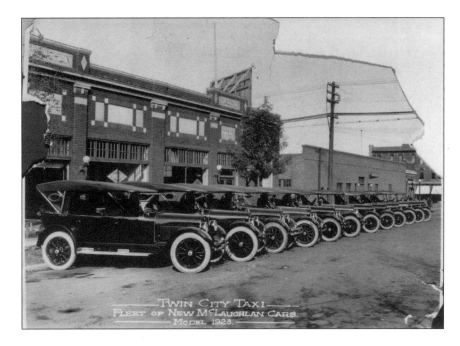

Twin City Taxi Cabs fleet, 1923.
COEA EA-423-53.

The Reverend George McDougall arrived at Fort Edmonton in 1871, claiming a piece of land for the Methodist Church. His original house of worship, shown left, was the first notable building outside the walls of the fort. The much larger brick structure to the right is McDougall United Church, built in 1909 and named in the Reverend's honour.

McDougall Memorial Museum and McDougall United Church, 1920s.
COEA EA-10-372.

In his ability to understand the value of recycling, René LeMarchand was a man far ahead of his time. As a Parisian butler, he had a wealthy employer whose eccentric habit it was to insist upon a fresh razor blade every time he shaved. LeMarchand enterprisingly sold the collection of once-used blades for an amount that was sufficient to finance his move to Edmonton and the construction of the city's first luxury apartment complex: LeMarchand Mansion.

The Mansion was completed in 1911, and boasted every cosmopolitan luxury and modern convenience of the day. It had Edmonton's first elevator, and was the first city building to be heated by natural gas. There were four storeys and forty-three suites, filled with elegant architectural details.

In 1916, René LeMarchand returned to Paris. His magnificent mansion has since passed through many hands, but is guaranteed to always be a part of Edmonton's landscape. It underwent a complete restoration, and was designated a provincial historic resource in 1977.

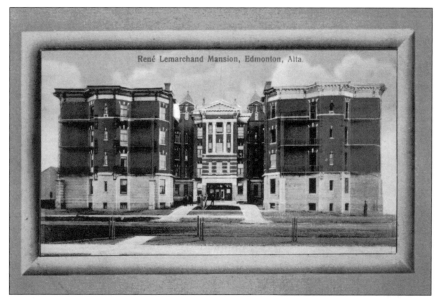

René Lemarchand Mansion, Edmonton, Alta.

LeMarchand Mansion.
COEA EA-10-605.

48

T wo members of Edmonton's fire department pose, with their vehicle, inside Number One Fire Hall. This photo must have been taken in winter, as the tires are equipped with snow chains.

Firefighters, circa 1910.
COEA EA-10-958.

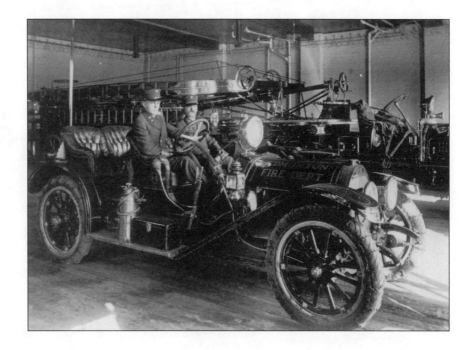

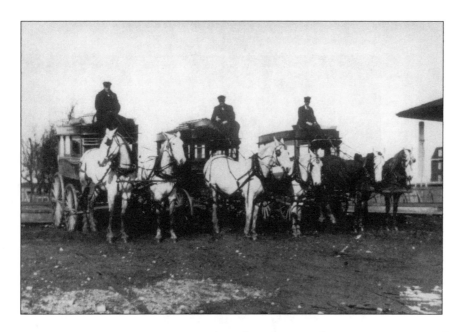

Strathcona-to-Edmonton stagecoach service, 1910.
COEA EA-10-1272.

Whyte Avenue, looking west, in 1910.
COEA EA-364-1.

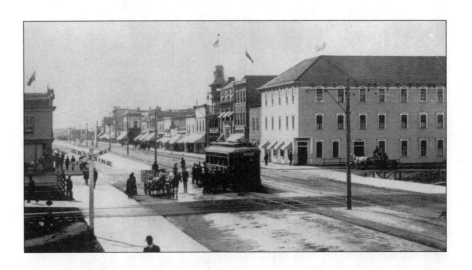

For decades, this distinctive building was a landmark in downtown Edmonton, but the early seventies saw it demolished to make way for a hotel (presently the Westin).

A bit of the landmark remains, however, for the clock was preserved and, in 1978, an anonymous donor financed the construction of a modern tower to house the original clock face and mechanism.

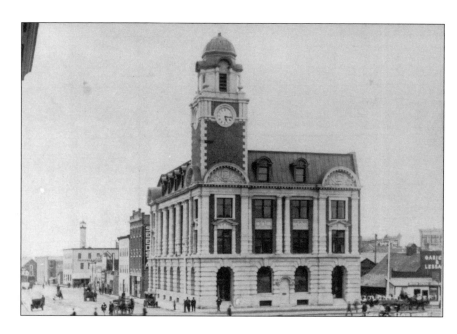

Main Post Office, 1910.
COEA EA-371-10.

Edmonton Bottling Works, 1911.
COEA EB-26-407.

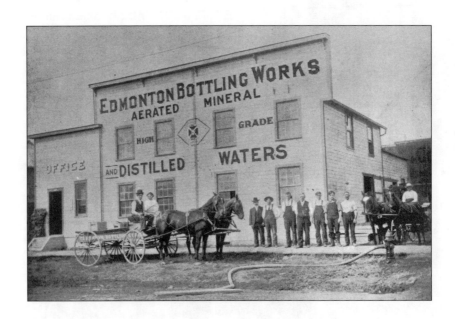

When Alex Decoteau joined the Edmonton Police Department in 1911, he became the first Native police officer in Canada. Although he would eventually rise to the rank of sergeant, and also hold the distinction of being the country's first motorcycle policeman, Decoteau is probably remembered less for his law enforcement career than for his athletic prowess.

Decoteau was a distance runner who won local races with such regularity, some organizers thought it simpler to award him their trophies permanently. He was the provincial champion in the half-mile, one-mile, two-mile, three-mile, five-mile, and ten-mile events, once winning four of them in a single day. And at the 1912 Olympics in Stockholm, Decoteau stood out as the only Albertan chosen for Canada's Olympic team.

In April of 1916, Alex Decoteau enlisted in the Canadian Army. Eighteen months later, he was killed in action at the battle of Passchendaele. He was not yet thirty years old.

In 1967, Alex Decoteau was named to the Edmonton Sports Hall of Fame.

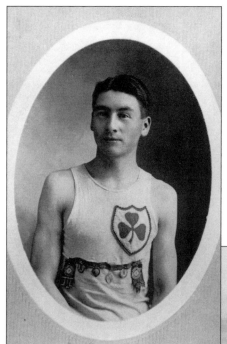

Alex Decoteau in his Shamrock Athletic Club vest, 1912.
COEA EA-10-2072.

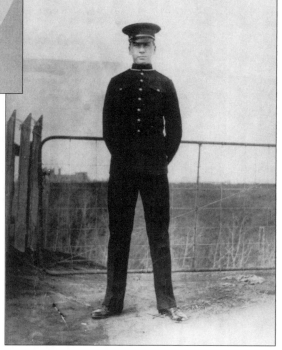

Alex Decoteau in uniform, 1911.
COEA EA-302-82.

54

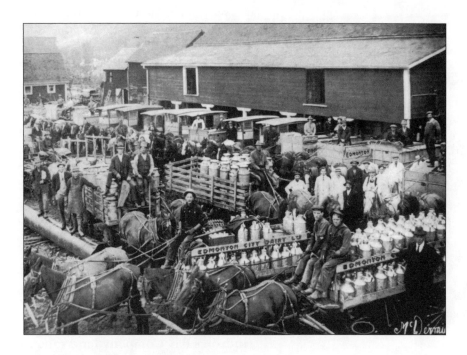

Edmonton City Dairy, 1912.
COEA EA-10-1359.

On May 13, 1912, hundreds of people lined up for a ticket draw, hoping for the number one that came with first choice of 1,500 lots released for sale by the Hudson's Bay Company. In the midst of Edmonton's real estate boom, the opportunity to buy a piece of the undeveloped land north of 107 Avenue was golden. What no one knew was that the boom market was about to go bust, and many lost their new property when they were unable to pay the taxes.

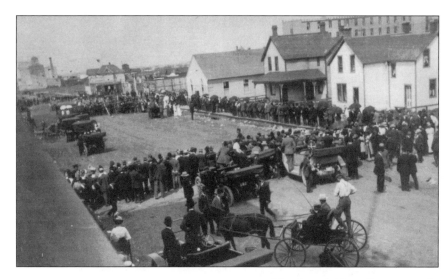

Hudson's Bay Company land sale, 1912.
COEA EA-10-2929.

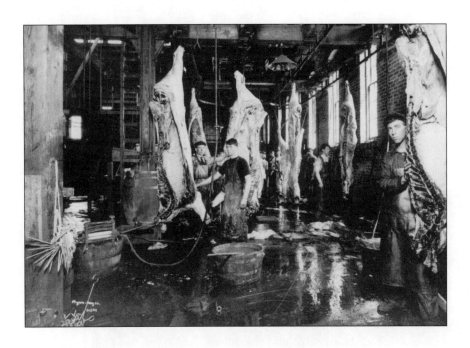

J.Y. Griffin Packing Plant, circa 1912.
COEA EA-500-241.

One of the first large economic benefits Edmonton enjoyed as a result of winning the capital was the construction of the Legislature. Excavation began in 1907, and on October 1, 1909, crowds gathered to witness as Governor General Earl Grey laid the cornerstone. Under that stone are a complete set of building plans, currency of the day, and copies of the three city newspapers published at that time.

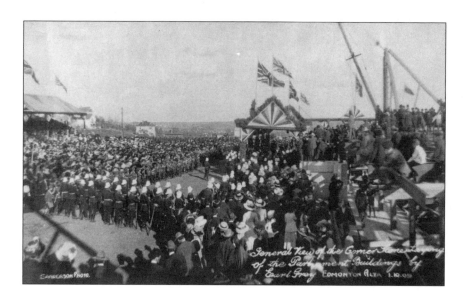

Laying the cornerstone of the Legislature, October 1, 1909.
COEA EA-34-10.

It wasn't the first crossing of the North Saskatchewan — the Low Level Bridge had been around for years. But the Low Level was functional and utilitarian and looked the part. In contrast, the High Level Bridge was an immense, highly publicized engineering marvel that would place Edmonton shoulder-to-shoulder with other bridge cities. In fact, at the time of its completion in 1913, only three other bridges in Canada exceeded it in size.

The High Level was designed to accommodate all forms of traffic; passenger vehicles and pedestrians on the lower deck, trains and streetcars above. And perhaps because it was so difficult at the time to fathom that such a massive structure could actually stand, people were hungry for statistics. They wanted to know that there were 100,000 bags of cement in its piers, and two million feet of lumber. That it took over eight and one-half tons of steel to span the river, and 1.4 million rivets to hold it all together. And that expansion plates compensated for the fact that the bridge was as much as twenty-four inches longer in the heat of summer than it was in the dead of winter.

There were many facts and stories involving Edmonton's great bridge; but the one that captures people's imaginations came not out of the construction, but out of a traffic jam in April of 1935. A baby girl was born in a taxi cab that was stuck on the bridge, and the *Edmonton Journal* sponsored a contest to see who could recommend an appropriate name for her. A twelve-year-old girl won with her suggestion of "Poncella," a rough French translation of "this one from the bridge."

The baby's full name was Olive Marie Poncella Beauchamp and, by all accounts, she was married and living happily in Ontario in 1990 when the bridge she was born on was designated a major civil engineering contribution to the growth and development of both the city and province.

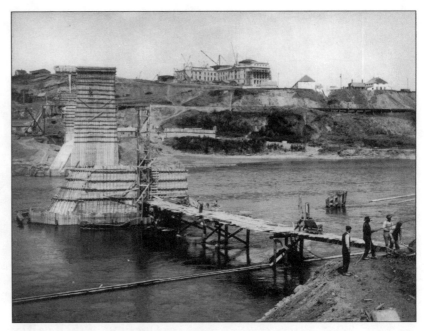

Construction of the High Level Bridge, 1911.
COEA EA-134-1.

On September 3, 1912, the Duke of Connaught, who was the new governor general, arrived to officiate over the grand opening of the magnificent Legislature Building. Part of the ceremony involved presenting the Duke with a solid-gold key to the main doors. It was an empty gesture; because despite the great rush to complete all work by the appointed date, many things were left unfinished. That included the hand-carved oak doors, which had no locks and, therefore, required no keys — gold or otherwise.

The Classical Revival Style building, with its impressive granite, sandstone, and marble surfaces, was a great source of pride to Edmontonians of the time. It proved the ability of a "frontier town" to compete architecturally with much larger cultural, economic, and political centres.

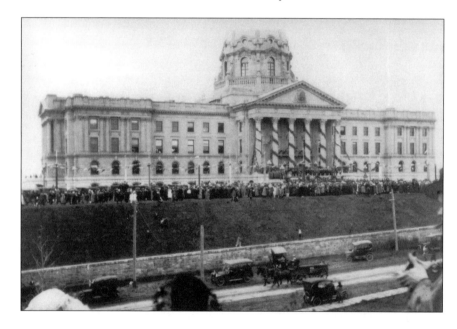

Opening of the Legislature Building, 1912.
COEA EA-471-14.

The Court House, at 100 Street and 102A Avenue, was built in 1911. For sixty years, both the Supreme and District Courts were held within its elegant oak-panelled walls. In 1972, it was a sign of dubious progress when the classical Greek columns, granite and sandstone exterior, and marble staircase came down to make way for a shopping complex.

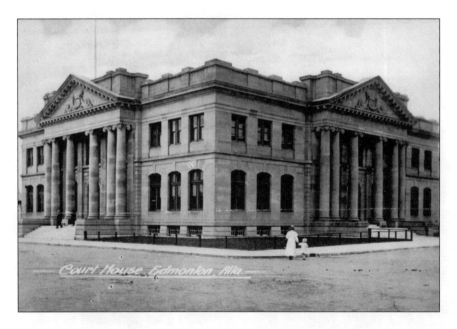

The Court House, circa 1912.
COEA EA-10-2788.

This grand temple of a building was constructed in 1907, on the site of Edmonton's first bank. It reflected the prosperity of the time, with its imposing columns, marble interior, and porcelain tile floor.

One feature worthy of note was a special "women only" room — said to be created for female customers who wished to deposit their real estate gains without their husbands' interference.

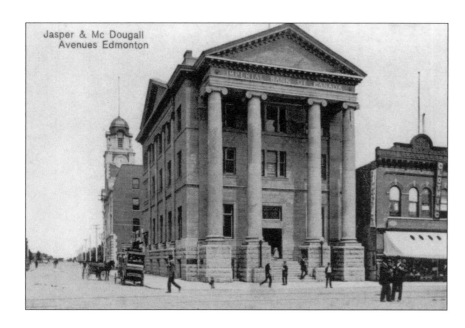

The Imperial Bank of Canada, Jasper Avenue, circa 1912.
COEA EA-10-283.

On September 18, 1912, the *Edmonton Journal* ran a headline declaring that a woman named Annie Jackson would be Edmonton's first "Woman Policeman." Jackson was, in fact, the first policewoman in all of Canada. This was considered so remarkable, Jackson's appointment was written up in newspapers as far away as Toronto (where they concluded that Edmontonian men must have been in short supply) and London, England (where the *Daily Mirror* described her duties as looking after "the morals and manners of Edmonton's young girls").

The *Mirror's* description was not far off the mark. Jackson was primarily concerned with cases involving girls and young women, and she served the police department in this capacity until her resignation in 1918.

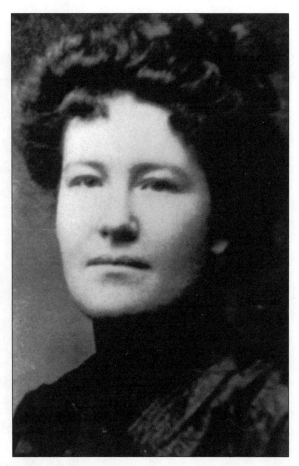

Annie Jackson, Edmonton's first policewoman.
COEA A90-80.

Bessie Nichols was voted in as an Edmonton school trustee in 1912, thereby becoming the city's first woman elected to public office.

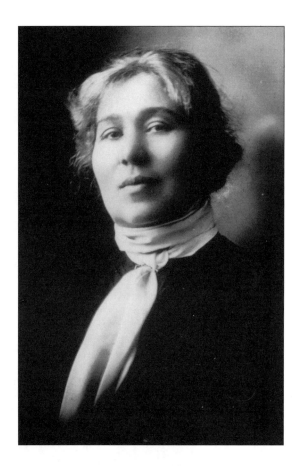

Bessie Nichols, 1912.
COEA EA-38-25.

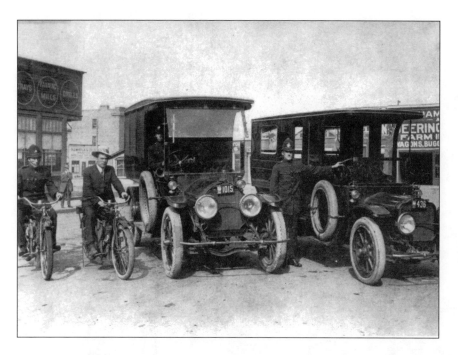

Edmonton police vehicles, 1913.
COEA EA-10-695.

I n 1913, Fort Edmonton still sat in view of the Legislative Building. Two years later, crews would dismantle the disused fort. Though conservationists were assured that the materials were all being marked, and that the historic building would be reassembled elsewhere, it never happened.

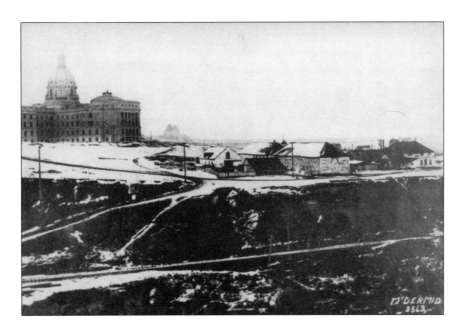

Fort Edmonton and the Legislature, 1913.
COEA EA-10-78.

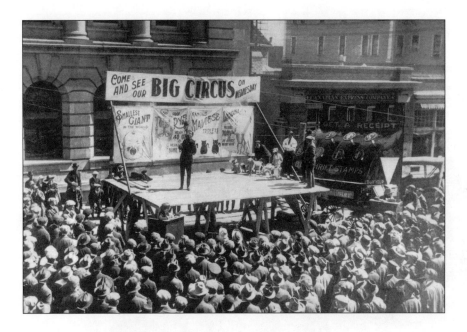

A circus in Edmonton, circa 1913.
COEA EA-10-1004.

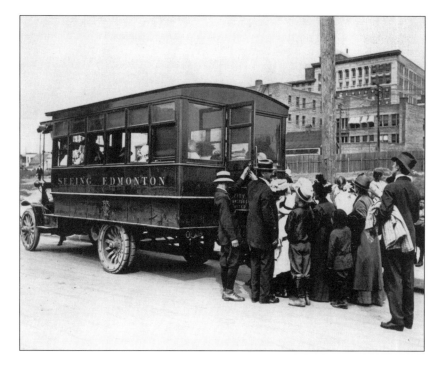

Sight-seeing in Edmonton, circa 1913.
COEA EA-10-1258.

The lights of Jasper Avenue, 1913.
COEA EB-23-5.

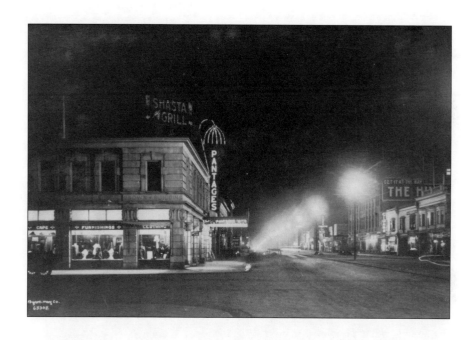

This 1913 photo shows a row of houses under construction in Edmonton. No matter how quickly they were being built, however, it was impossible to properly house the city's swelling population at that time.

When Edmonton and Strathcona merged in February of 1912, their combined numbers totalled roughly fifty thousand. A short two years later, the population peaked at 72,516 people. Those unable to secure decent lodging resorted to tents and dangerously overcrowded rooming houses. An outbreak of typhoid fever in 1912 was traced to rooming-house congestion; the health inspector found one two-storey dwelling with a total of sixty single beds and no sanitary facilities.

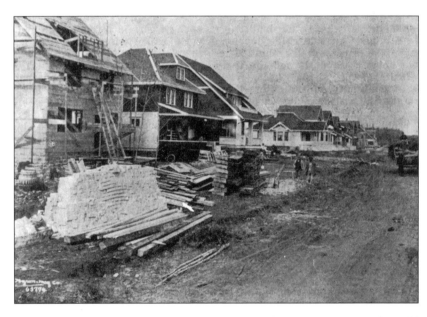

House construction, 1913.
COEA EA-267-262.

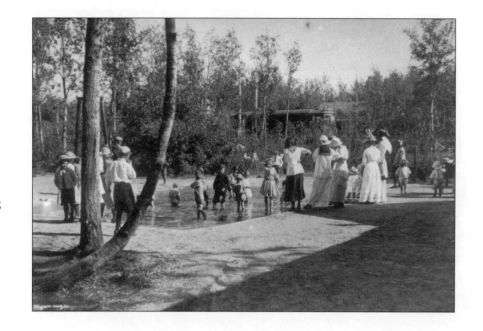

**Afternoon in an east end park;
summer of 1913.**
COEA EA-10-2926.6.

A pleasant winter's day would bring many out to enjoy some ice-skating on McKernan Lake. The area, named for the family who settled and farmed there, was also a popular spot for picnics and boating in the summer months — but popularity was not enough to save the little lake from the effects of urban growth.

McKernan Lake was drained in 1948, during a post-war building boom that saw housing developments swallowing farmland, wetlands, thick brush, and former landfill sites. The loss of the lake made room for approximately 150 new homes around the area of 73 Avenue and 111 Street. When those very homes flooded in the early 1950s, some billed it as McKernan Lake's "ghostly return."

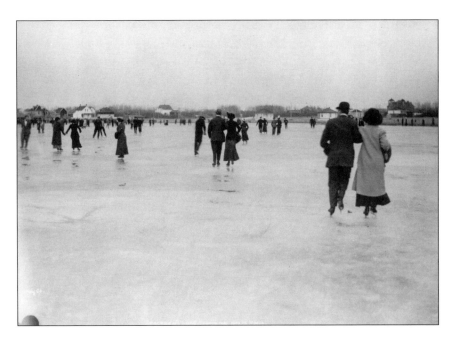

Ice-skating party on McKernan Lake, 1913.
COEA EA-10-2219.

Edmonton recorded its first traffic accident on April 27, 1893, when a Mr. Finch's cart collided with a Mr. Osborne's buggy at the corner of 101 Street and Jasper Avenue. Excess speed was thought to have been a factor.

Two decades later, the potential for traffic mishaps had increased terrifically. This 1914 photo shows Jasper Avenue teeming with pedestrians, horses and carts, automobiles, and streetcars.

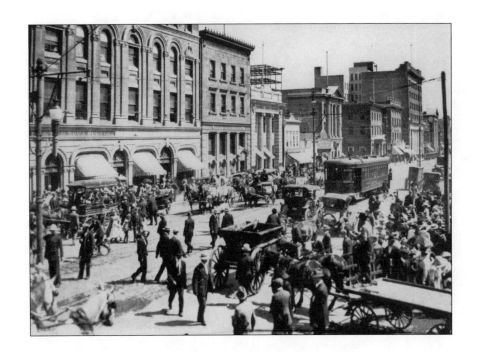

Jasper Avenue, 1914.
COEA EA-63-11.

On February 22, 1913, Edmontonian John Hougan shattered Canada's ski jump record and thrilled a crowd of four thousand cheering spectators when he leaped 109 feet down Connors Hill. He broke the existing record by five feet that day, and would go on to better his own record by an additional three feet the following winter.

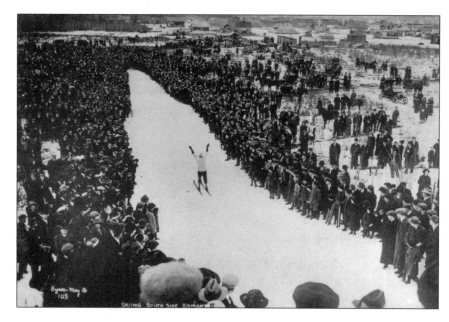

John Hougan setting Canadian ski jump record, 1913.
COEA EB-23-28.

It was June 28, 1915, when the North Saskatchewan River rose an astounding forty-four feet, covering thirty-five city blocks and forcing the evacuation of hundreds of families from the valley.

While the water climbed at a rate of one foot each hour, a fleet of trucks and drays were mobilized, and they worked throughout the night in an attempt to save furniture and personal effects. A tent town for evacuees was established on the grounds of the new Legislature Building and, from that high ground, people watched helplessly as the swollen river carried away belongings, livestock, and even entire houses. Other homes bobbed in the current like buoys, having been tethered down with strong ropes by their fast-thinking owners.

By the next morning, even those who lived on high ground were feeling the effects of the disaster. The power plant and water works, both located on the flood plain, were forced to shut down for twenty-five hours. Edmontonians lived without the convenience of utilities, and banded together in an effort to help the two thousand people left homeless. Realty firms and average citizens made available a number of empty houses, apartments, and rooms, and the city's newly formed Board of Public Welfare worked overtime collecting goods and money to aid the victims.

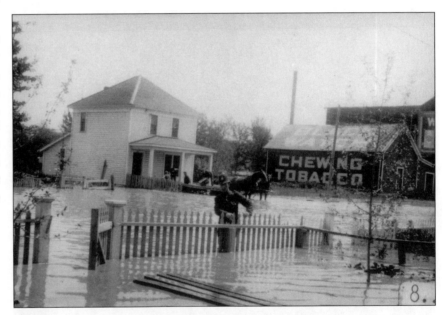

A police officer walks his beat during the flood, 1915.
COEA EA-25-41.

75

At the height of the 1915 flood, there was great concern that the Low Level Bridge would be washed away. The river had risen to within scant inches of the bridge deck, and the structure was being battered relentlessly by huge amounts of debris.

In a desperate effort to steady the bridge against the strain of the water, a long string of heavily loaded CNR freight cars was run across it. Although the locomotive kept up full steam pressure for a quick getaway, one was never needed. The bridge stayed put.

Ironically, that was owed, in part, to a previous flood. It happened in 1899, during the construction of the Low Level. When the waters covered the newly built piers by more than six feet, the engineers decided to build them higher. It was wise thinking, because in 1915, the river *rose* higher.

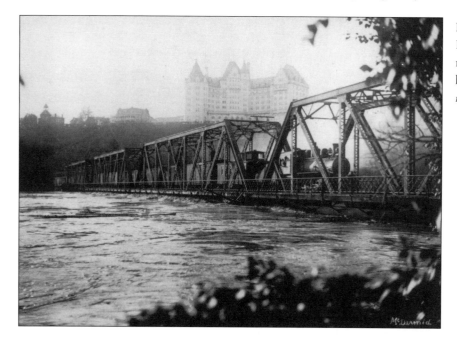

Train secures Low Level Bridge during 1915 flood.
COEA EA-160-1399.

B y the evening of June 29, 1915, it was over, and Edmonton began tallying the cost of the worst natural disaster in its history.

The sodden streets of the river valley were thick with mud, and dotted with pools of dirty water. Homes that had not been carried away were filled with silt, and were far too damaged to live in. Animals and possessions were lost. Many businesses, including John Walter's mills, would never come back.

When all was said and done, damage was estimated at over one million dollars, and the river valley would never be rebuilt as an industrial area.

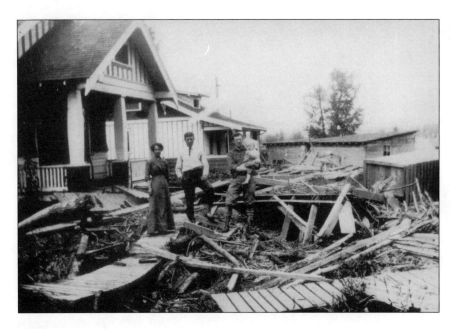

1915 flood damage.
COEA EA-25-1.

The castle-like Macdonald Hotel, built by the Grand Trunk Pacific Railway for an estimated $2,250,000, opened on July 5, 1915. Its distinctive design and position overlooking the river valley immediately established the "Mac" as a city landmark.

Unfortunately, its completion marked the end of Edmonton's pre-war construction boom and the beginning of a period of high unemployment.

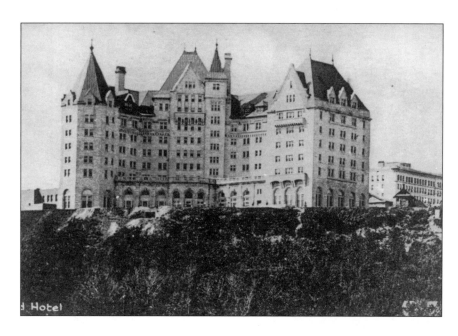

Macdonald Hotel, circa 1915.
COEA EA-102-1.

Secord House; winter of 1915.
COEA EA-9-340.

Someone took care to write the date — March 19, 1916 — on this photo of Chamberlin House. A good look at the fence explains why.

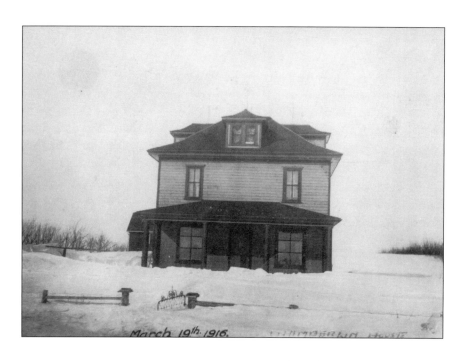

Chamberlin House, 1916.
COEA EA-246-126.

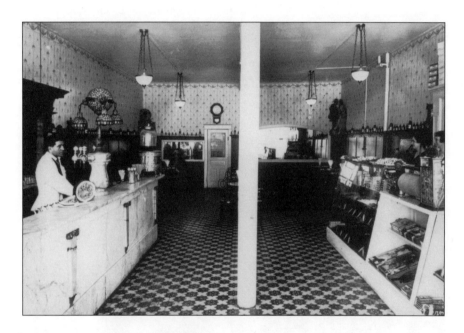

A Jasper Avenue ice cream parlour, circa 1916.
COEA EA-160-187.

The first air mail delivery in Western Canada was staged as a publicity stunt for the 1918 Edmonton Exhibition. American aviatrix Katherine Stinson made the flight from Calgary to Edmonton in just over two hours, and landed in front of the grandstand at the Exhibition Grounds. This photo was taken as she handed the mail over to Edmonton's postmaster.

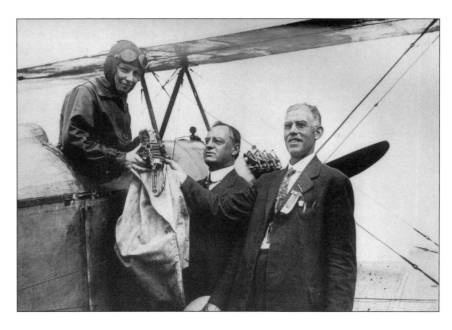

First air mail delivery, 1918.
COEA EA-10-1246.

Crowds of people enjoyed the midway at Edmonton's 1919 Exhibition. This was the fortieth anniversary of the annual event that began as an agricultural fair on the grounds of the fort.

At that first exhibition in 1879, a good portion of the populace from Edmonton, Fort Saskatchewan, St. Albert, and all surrounding farms came to witness and participate in competitions for the best livestock, vegetables, and women's handiwork. A total of $173 in prize money was available — a person could take home two dollars for the best pumpkin, another two for the best fat ox, four for the best potatoes, or a special ten-dollar award, granted by the government of the Northwest Territories, for the finest wheat.

By all accounts, that first Exhibition was a success. There were some problems the second year, however. The treasurer of the event died while holding a surplus of $139 in his personal bank account, and his widow refused to give back the money.

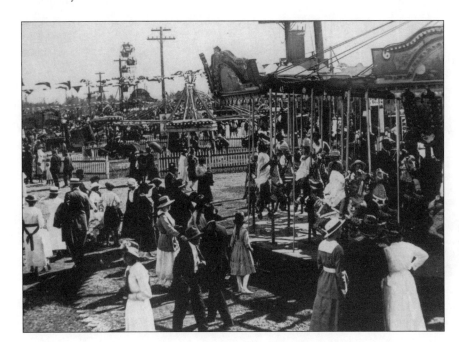

Exhibition midway, 1919.
COEA EA-10-2132.

In the fall of 1918, as World War I drew to a close, Edmonton was devastated by another killer: Spanish Influenza. It was a deadly virus carried to Canada unwittingly by our country's first returning soldiers. World-wide, the Spanish Flu claimed 25 million lives within six short months — so when the first cases were reported in Edmonton, panic set in quickly.

Sidewalk spittoons were immediately abolished, and churches, schools, and theatres closed — some to reopen almost immediately as makeshift hospitals, staffed by inexperienced volunteers. Business hours and public gatherings were restricted; if you got married during the epidemic, there could be no more than twelve people at the ceremony.

And by the end of October, the provincial government had ordered all people to wear cloth masks when outside their homes.

All the newspapers published simple instructions for making flu masks out of cheesecloth. It was later understood that the masks would have done little to stop the spread of the highly contagious disease and, in fact, if worn for too long, would have actually become a good medium for the growth of the virus.

Within a few weeks, 450 Edmontonians had died of the flu.

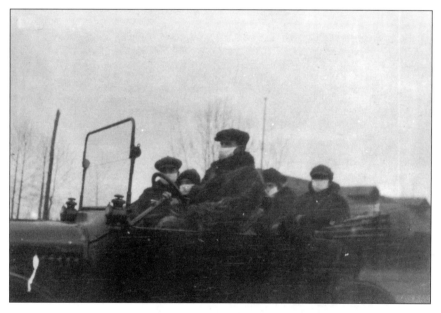

Flu masks, 1918.
COEA EA-10-2767.

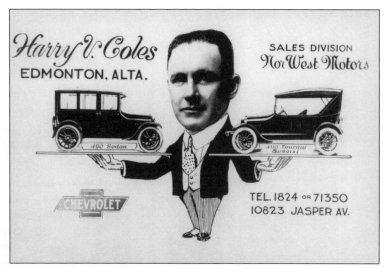

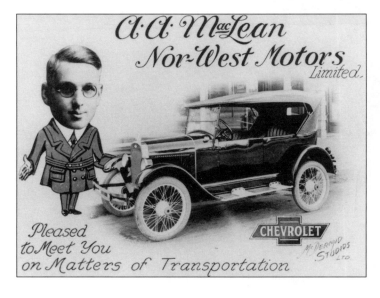

NorWest Motors advertisements, 1920.
COEA EA-160-39 and EA-160-40.

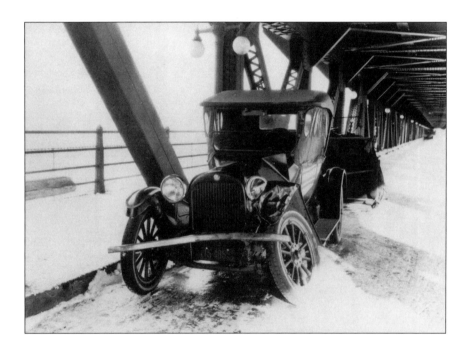

Automobile accident on the High Level Bridge, 1922.
COEA EA-160-70.

Auto repair garage, June 1923.
COEA EA-160-113.

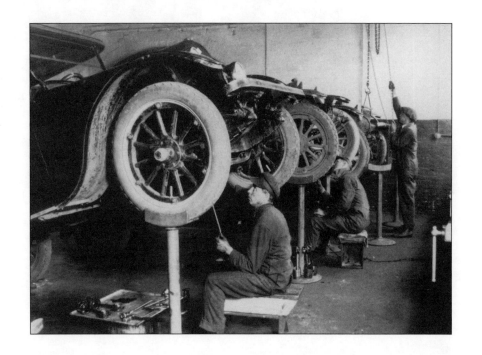

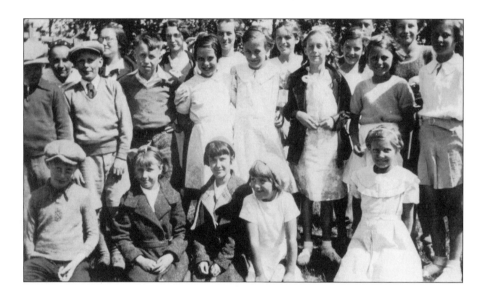

Children attending a picnic, 1920.
COEA EA-10-723.

A family enjoying refreshments at the South Cooking Lake Store, circa 1920.
COEA EA-226-50.

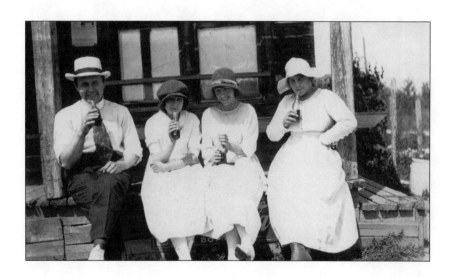

This portrait of the Edmonton Newsboys' Band was taken in August of 1921, a little more than seven years after the group began.

Newsstand owner John Michaels, who was concerned about juvenile delinquency, formed the band to give young boys something constructive to fill their time. Members had to be paper carriers, but musical experience was not required.

Led by bandmaster R.A. Bullock, the Newsboys held their first practise in the basement of Alex Taylor School in March of 1914. On that evening, no one would have guessed that the band would last for fifteen years, see hundreds of members, and travel across the country and overseas.

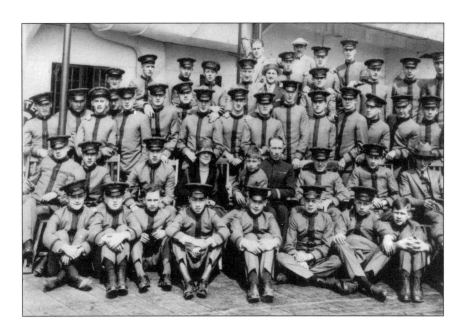

The Edmonton Newsboys' Band.
COEA EA-502-4.

The Newsboys' Band enjoyed great city-wide popularity — they played at most of the Edmonton Grads' basketball games, took part in countless concerts and parades, and were on hand to send Edmonton's soldiers off to the First World War, and then to welcome them home again. They were hometown heroes, but quickly became recognized away from Edmonton, too, as one of Canada's premier brass bands.

In their heyday, the Newsboys played across Canada, and in the United States. Ultimately, in 1924, they travelled to England — as the only Canadian band invited by the Prince of Wales to play at the British Imperial Exhibition in Wembly. While there, they played Edmonton's namesake city in England, drawing an incredible crowd of 35,000 people. It was heady success for the fifty-member band whose average age, at the time, was just 17.

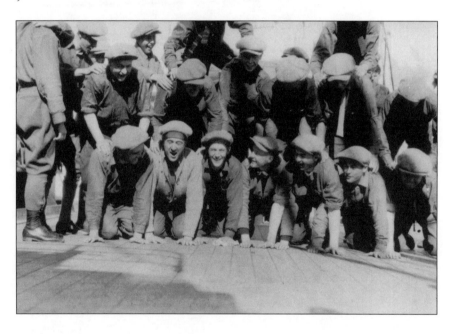

The Edmonton Newsboys aboard the S.S. *Montcalm*, July, 1921.
COEA EB-25-141.

It was May 1, 1922, when Edmonton's first radio station, CJCA, began broadcasting from a corner of the *Edmonton Journal* newsroom. It was estimated that there were only two hundred radio receivers in the city at that time; nevertheless, two other stations immediately joined CJCA in competition for the small listening audience.

For some time, all three stations shared the same frequency, taking turns throughout the broadcast day. This cohabitation of the airwaves ended quickly one night, when CJCA was broadcasting a Dempsey-Tunney boxing match. The fight ran long, but listeners never heard the final rounds, as station CHCY (the International Bible Students Association) cut in at their pre-appointed time. When it was all over, the Bible students lost their licence and CJCA was granted a frequency of their own.

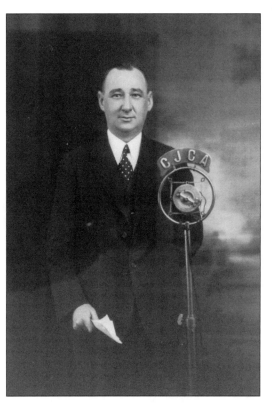

R.W. Drake with CJCA Radio microphone, circa 1922.
COEA EA-244-6.

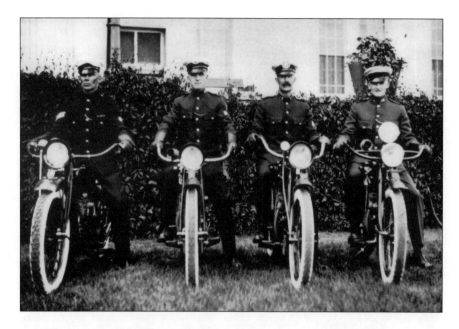

The Edmonton City Police Traffic Division, 1922.
COEA EA-159-1.

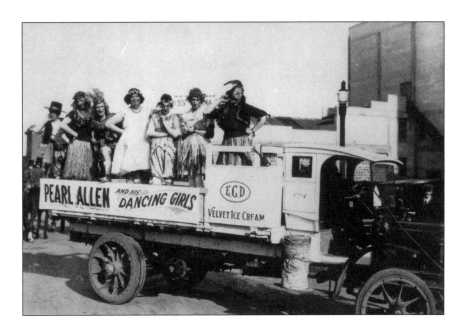

The Edmonton City Dairy Exhibition Parade float, 1922.
COEA EA-160-122.

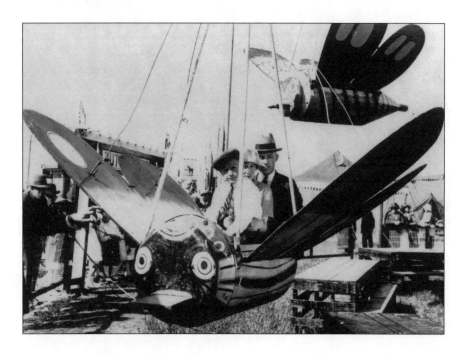

Bee Ride at the Exhibition midway, 1922.
COEA EA-160-172.

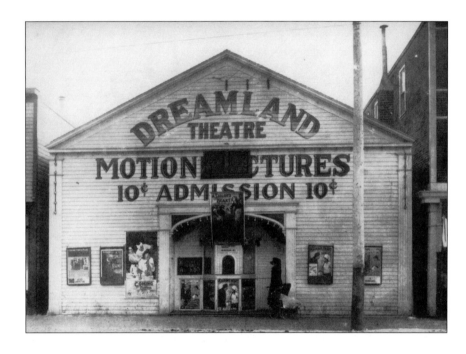

Dreamland Theatre, Jasper Avenue at 97 Street
COEA EA-10-657.

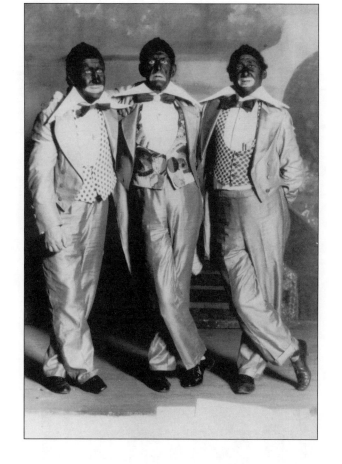

The Rotary Minstrel Show, circa 1922.
COEA EA-244-7.

When the Princess Theatre opened in March of 1915, it held the distinction of being the first marble-faced building west of Winnipeg. This touch of opulence no doubt contributed to the theatre's $75,000 price tag, but also to its lasting appeal. The Princess remains open to this day.

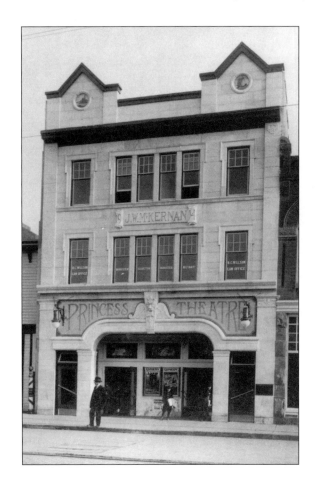

The Princess Theatre, circa 1915.
COEA EA-519-1.

**Great Society Drama
advertisement, circa 1922.**
COEA EA-160-443.

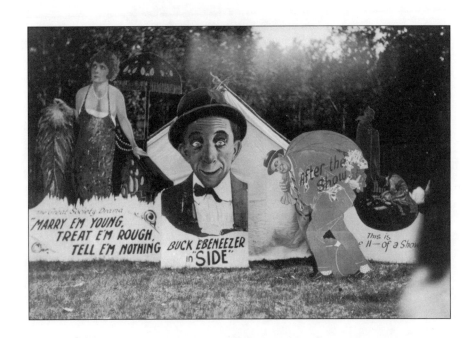

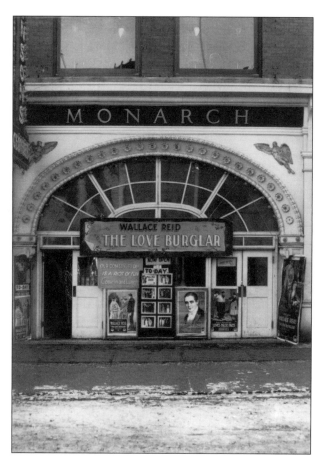

The Monarch Theatre, February 27, 1920.
COEA EA-160-217.

The sign painted on the north wall of the building always said it best: "Pantages Theatre — Unequalled Vaudeville."

It was a promise well-kept, from the spectacular opening night in May of 1913. As part of the largest independently owned vaudeville circuit in North America, this Pantages drew acts as great as any seen in much larger cities. For as little as fifteen cents (the price of a matinee ticket), Edmontonians were entertained by the likes of the Marx Brothers, Buster Keaton, Will Rogers, and Sophie Tucker. Stan Laurel performed here, even before teaming up with Oliver Hardy, and comedian Joe Yule once carried onstage his infant son, who would grow up to become Mickey Rooney.

And there was no doubt that the theatre itself was a part of the show. Created in the grand tradition of vaudeville palaces, the Pantages was richly ornate — finished throughout with imported Italian and Grecian marble, Chinese silk wall panels, hand-painted murals, and sumptuous draperies trimmed with hand embroideries. But despite its appealing grandeur, when vaudeville died, so did the Pantages. It closed in 1930.

The following year, the theatre reopened as the Strand. It now showed the increasingly popular "talkies," and would become the place from which Premier William "Bible Bill" Aberhart would broadcast his famous Sunday night sermons.

Because of its architectural and historical significance, the Pantages/Strand was registered as a Provincial Historic Site in 1976. Unfortunately, the designation was not enough to save the grand old theatre. The home of "Unequalled Vaudeville" was demolished in 1979.

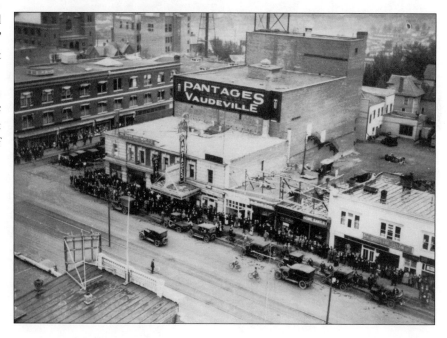

Crowds line Jasper Avenue in front of Pantages Theatre, March 10, 1923.
COEA EA-160-24.

101

The Edmonton Grads basketball team, October, 1923.
COEA EA-160-192.

More than half a century before Edmonton began calling itself the "City of Champions," it was home to one of the greatest championship teams the world has ever seen: The Edmonton Commercial Graduates.

From 1915 through 1940, the Grads were the most famous and celebrated basketball team in the world, setting records and winning championships until they had compiled an incredible list of sporting achievements that will likely never be equalled. And part of the story's appeal was that it all began so simply: with a high school basketball team formed by the girls of the commercial classes at John A. McDougall school.

The girls enjoyed the game so much, they were reluctant to give up playing after graduation. They convinced their teacher, J. Percy Page, to keep coaching them, and on June 15, 1915, formed the Commercial Graduates basketball team. It was the inauspicious beginning of a dynasty.

In the twenty-five triumphant years that followed, the Grads dominated women's basketball. Using Page's system of play, they hit the court 522 times — and won an unbelievable 502 of those games. The team won their first Canadian championship in 1922, and never lost it thereafter. They took the North American championship twenty-five times (the trophy was permanently awarded to them when they retired) and

were world champions on sixteen occasions. And at the Olympics in 1924, '28, '32, and '36, Edmonton's own Grads stunned the world as they swept twenty-seven consecutive exhibition games. Dr. James Naismith, inventor of the game, called the Grads "the greatest club that ever stepped on a basketball floor." And it was true: their success was simply unparalleled.

Despite the fact that the team was never sponsored — the players all held day jobs — the Grads logged over 125,000 miles travelling to competitions around the world. In doing so, they put Edmonton on the sporting world's map, and were considered unofficial ambassadors of the city until they disbanded.

It was in 1940 that the Grads ended their own reign of success. The simple explanation from Percy Page, who had coached the team through twenty-five consecutive seasons, was that a number of their star players were retiring and replacements were scarce. "We should stop while we're still champions," he said, ending the most amazing chapter in basketball history.

The more likely explanation was that the Grads were victims of their own success. There were no other teams that could provide real competition, and even the most loyal Grads fans were unwilling to pay to see a game where the outcome was so certain. Edmonton's magnificent Commercial Graduates probably retired because they were legends — who could no longer sell tickets.

Still, nothing could cast a shadow on what the team had achieved. As George Mackintosh, a former *Edmonton Journal* sports editor, summarized at a Grads' reunion: "Your story has been told for forty years. It will be told for forty more, and if it is told for forty more after that, it still will never lose its lustre."

Indeed, it has not.

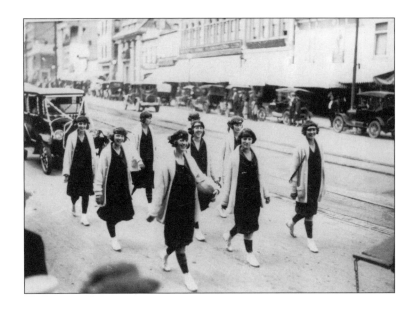

Grads in Edmonton Exhibition parade, 1923.
COEA EA-160-189.

Edmonton Journal **tribute to the Grads, June 4, 1940.**
COEA EA-267-463.

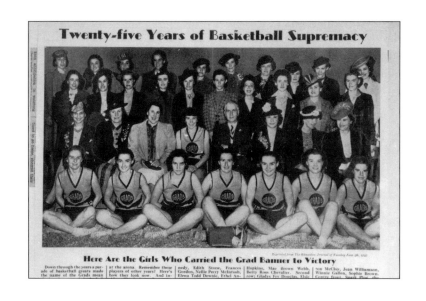

In 1921, Edmonton had ten separate community leagues in operation. In January of that year they joined together to form the Federation, which would go on to become the largest volunteer organization in North America.

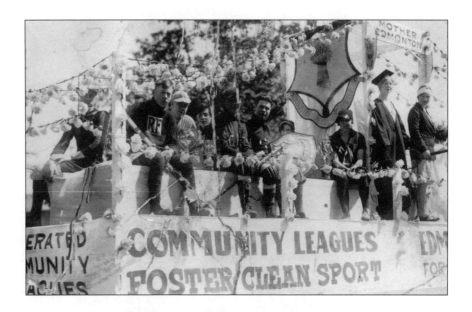

The Edmonton Federation of Community Leagues float, circa 1925.
COEA EA-413-11.

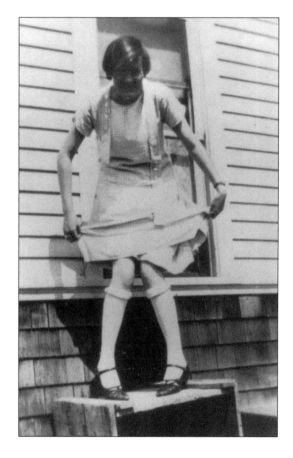

Girl dancing the Charleston, 1926.
COEA EA-462-131.

This little girl was enjoying the summer sun in 1927, but it would be another full decade before Edmonton had its record-setting hottest day. It was June 29, 1937 that the mercury rose to a sweltering 37.2 degrees Celsius (99 degrees Fahrenheit).

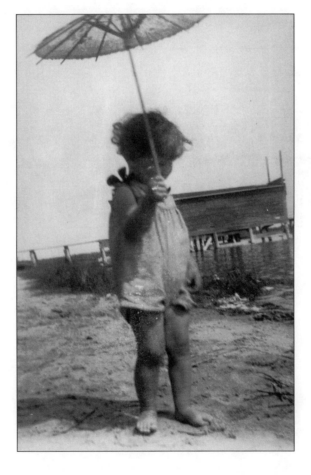

Toddler sunbathing, 1927.
COEA EA-226-337.

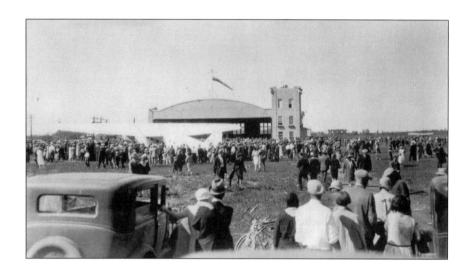

Spectators at Blatchford Field (Edmonton Municipal Airport), 1930.
COEA EA-67-1.

Emily Murphy was once quoted as saying "All women must stop smothering themselves in chiffon and put on something sturdy and go to work." She was clearly a woman who took her own advice, and, in a lifetime of such self-prescribed work, managed to change not only Edmonton, but all of Canada.

The well known author (who published under the pen name "Janey Canuck") first drew attention in Edmonton in 1911 when she orchestrated the passage of the Dower Act, ensuring a wife's right to one-third of her husband's property. Two years later, Murphy's name was spoken around the world when she became the first female magistrate, not only in Edmonton, but in all the British Empire. Still, it was not until Murphy began ambitiously eyeing a position in the Senate that she would start down the path to her most notable achievement.

Emily Murphy, along with Nellie McClung, Irene Parlby, Louise McKinney, and Henrietta Edwards, formed Alberta's "Famous Five"; the group who challenged the Supreme Court of Canada's assertion that women were not "persons" in the eyes of the law — and therefore, along with "lunatics, criminals, and children," were unfit to serve in the Senate. The Famous Five appealed the ruling to the Privy Council in London and, in October of 1929, it was declared that women were indeed "persons" under the British North America Act.

In the end, however, Murphy's actions did not gain her the desired Senate appointment. Ironically, in her fight to tear down the legal barricade that barred her from the chamber, she may have built an equally formidable hurdle of prejudice against her. Still, her victory ensured that no other women would be denied access to any profession or office due to an outdated and unfair legal definition.

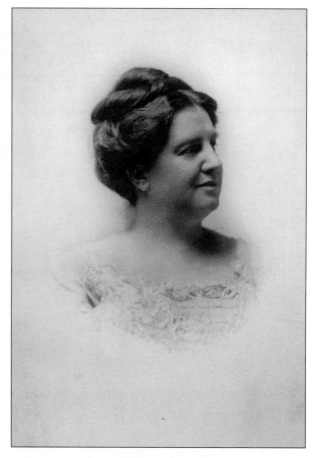

Emily Ferguson Murphy, 1912.
COEA EA-10-1987.

109

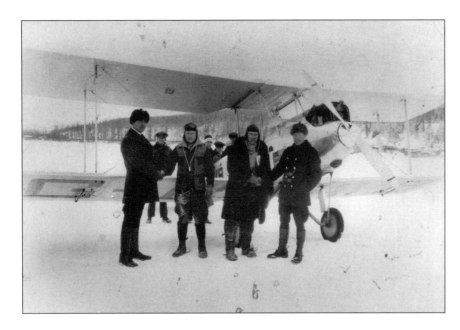

Pilots May and Horner embark on 1929 "mercy flight."
COEA EA-160-1608.

In World War I he was a fighter pilot in the Royal Flying Corps who was instrumental in bringing down the German ace Baron Von Richthofen, better known as "The Red Baron." Back home he gained fame as a stunt pilot before founding one of Canada's first commercial aviation companies. He established the Municipal Airport and the Edmonton Flying Club, and pioneered many northern routes that would secure Edmonton's position as the gateway to the north. He was the first pilot to aid the RCMP in a man-hunt when the "Mad Trapper," Albert Johnson, made his famous getaway into the bush. He was the father of Canada's air force search and rescue, and the recipient of the Distinguished Flying Cross, the Order of the British Empire, and a place in the Aviation Hall of Fame. He was Wilfrid "Wop" May, and he wrote history in the air.

In his extensive list of accomplishments, however, one famous flight did more than any other to secure May's proud place in Edmonton's history. It happened in January of 1929, and became known, simply, as the "mercy flight."

When a diphtheria epidemic threatened an isolated northern community, the only hope was that an emergency supply of antitoxin might be flown in to Fort Vermilion. The Deputy Minister of Health brought his request to the Edmonton Flying

Club, and was told there was one plane capable of the treacherous winter journey. It was a two-seater Avro Avion, owned by pilots Wop May and Vic Horner. They agreed to make the six-hundred mile flight.

The plane had an open cockpit and no heater, and the January temperatures were in the -30 range. A charcoal heater was found — not for the pilots, but to keep the antitoxin from freezing. Unfortunately, the heater caught fire at one point, and the fliers were forced to land and douse the flames with snow. For the rest of the flight, May and Horner protected the precious serum from the sub-zero temperatures by storing it in their armpits and groins.

That was only one of the challenges the men faced. Poor visibility forced the plane down so low, for much of the journey it was barely skimming over the treetops. The headwinds were vicious, the instruments froze, and the tiny, seventy-five horsepower engine threatened to fail as it sputtered along in the cold. After one overnight stop, the aircraft was so coated with ice it had to be thawed with blowtorches; its oil drained and warmed on a primus stove before the pilots could embark on the next leg of the journey.

Refuelling along the route also proved to be an adventure. At one point, the biplane came in for its scheduled stop in Peace River with only one gallon to spare. After filling up, the plane was so heavy, it couldn't clear a bridge in its path during take-off. Wop May relied on his years of barnstorming experience, and flew the Avion under the bridge deck between the piers.

In the end, it was worth it. The diphtheria antitoxin was delivered safely into the hands of the doctor at Fort Vermilion, and the first patient was the only one to die.

Back in Edmonton, May and Horner received an appropriate hero's welcome. Ten thousand people, who had listened faithfully to CJCA Radio's reports of the mission and read the *Edmonton Journal's* descriptions of the pilots as "angels of mercy" and "knights of the air" were on hand to greet them. The men were so cold, they had to be lifted from the cockpit, but they had earned a place in history, and in the hearts of Edmontonians.

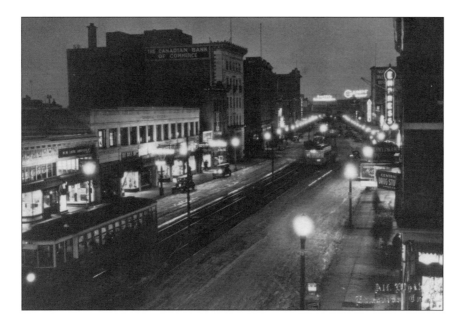

Jasper Avenue at night, 1930.
COEA EA-10-226.

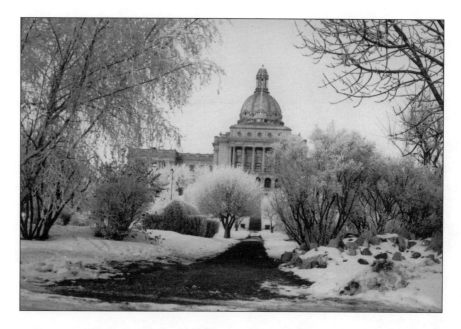

The Alberta Legislative Building in winter, 1932.
COEA EA-160-867.

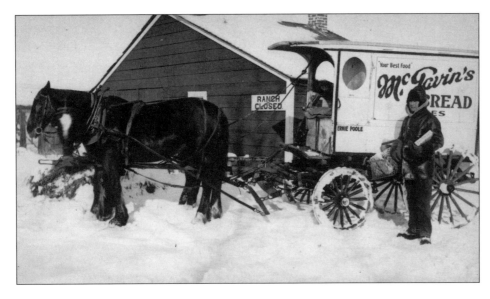

McGavin's Bread wagon, 1931.
COEA EA-160-1451.

On October 24, 1929, Wall Street crashed, marking the beginning of the Great Depression. In those ten terrible years, a shattered economy, combined with drought, slashed Canada's national income by 50 percent — and the agrarian prairie provinces were hardest hit.

Edmonton suffered the sting as construction ground to a halt, businesses laid off employees, and unemployment rose sky-high. And, even in the city, the troubles of the farm were keenly felt as families from dust-caked southern Alberta poured through Edmonton, following stories of better conditions in the north. Their beaten vehicles loaded with meagre possessions were a sad but common sight on the streets.

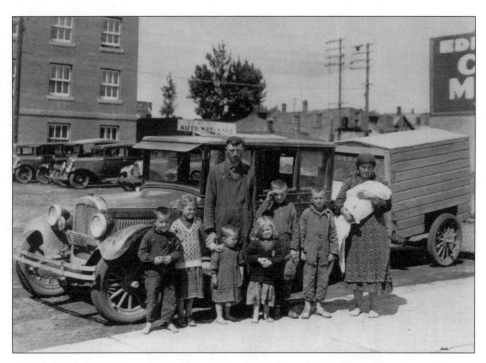

Destitute family passing through Edmonton, June 28, 1934.
COEA EA-273-44.

Even in the worst days of the Depression, there were many too proud to accept government relief. In Edmonton, some of those people came together in an odd community of their own; a shantytown built on Grierson dump.

Living in holes cut into the river bank, and crude shacks fashioned out of scrap material from the dump, as many as sixty-five men earned a scant but independent living by chipping coal out of abandoned mine shafts and selling salvage. Sifting through refuse for bottles, scrap metal, or usable car parts paid as much as two dollars per week which, little as it was, was more than a man could earn in the relief camps.

Ironically, when the economy began to improve, the population of Edmonton's shantytown suffered for it. Because people had more money to spend on new items, they stopped patronizing the Grierson dump entrepreneurs. One resident summed it up for a reporter: "…now that they're better off, it's us fellows that are taking the beating." (*Edmonton Journal,* February 14, 1938)

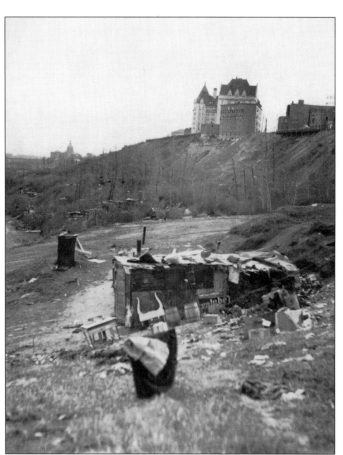

Macdonald Hotel overlooking shantytown on Grierson dump, circa 1938.
COEA EA-160-325.

116

The thirties was a decade of protest, as desperate people organized and marched in a futile effort to bring about better conditions.

Emotions ran high at such events, and the bitter sentiments expressed on the placards carried by these men were common. Sometimes violence was the inevitable result: only eighteen months before this demonstration, a rally in Edmonton's Market Square ended badly, with two hours of brutal confrontation between protesters and police.

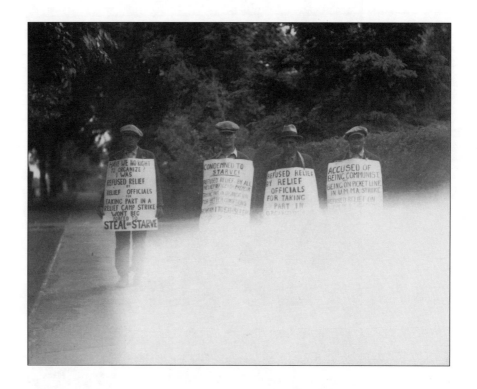

Unemployed demonstrators, June, 1934.
COEA EA-160-637.

1937's May Day demonstration parade.
COEA EA-160-1249.

The *Daily Clarion* parade float, 1937.
COEA EA-160-1239.

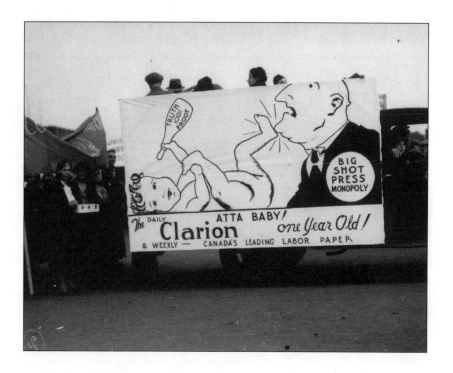

When Depression-era farmers could no longer afford gasoline for their vehicles, they would hitch teams of horses or oxen to them. This hybrid form of transportation became known as the "Bennett Buggy," named for Conservative Prime Minister Richard Bedford Bennett, whose economic policies failed to ease the misery of the early thirties.

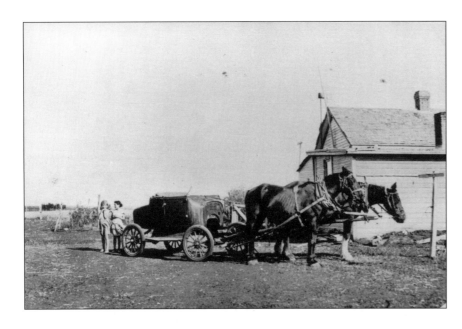

A "Bennett Buggy" of the 1930s.
COEA EA-255-11.

120

When the harsh economic conditions of the 1930s rendered people destitute, they could turn to government relief for help. For a population that had never known welfare, the charitable vouchers were difficult to accept. Even more difficult was the cruel fact that relief amounts were nearly impossible to live on. Couples with six or eight children were granted thirty five dollars per month to provide food, shelter, and all the other necessities of life. This was a bare subsistence for a large family, considering that rent could cost fifteen or more dollars, bread was six cents a loaf, milk ten cents a quart, and beef ten cents a pound.

In return, people were expected to do "relief work" — clearing streets, weeding boulevards, or performing any number of other chores the city created. It was harder yet for single men, who were only eligible for assistance if they laboured on roadbuilding or lumbering crews in army-run relief camps.

When the city's economic health returned, so did its pride. By as early as 1942, many people who had accepted Depression-era relief had actually repaid the government, in full.

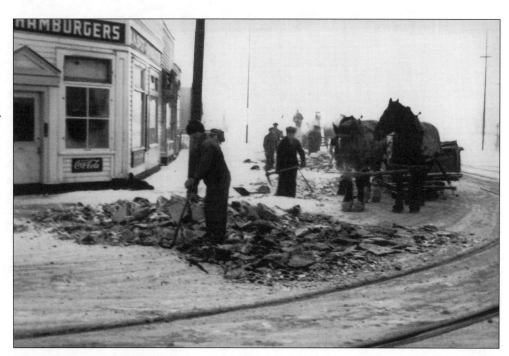

Relief work: clearing ice off Edmonton streets, 1939.
COEA-160-1053.

121

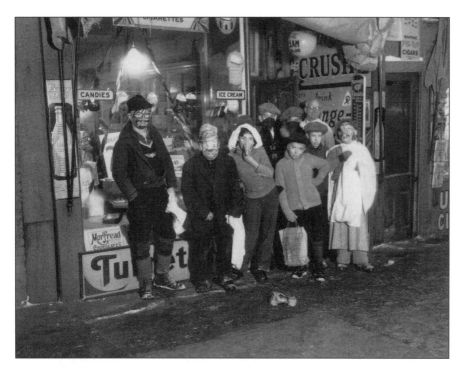

Hallowe'en, 1933.
COEA EA-160-530.

Watching 1933 World Series baseball scoreboard, on the *Edmonton Journal* **building.**
COEA EA-160-1513.

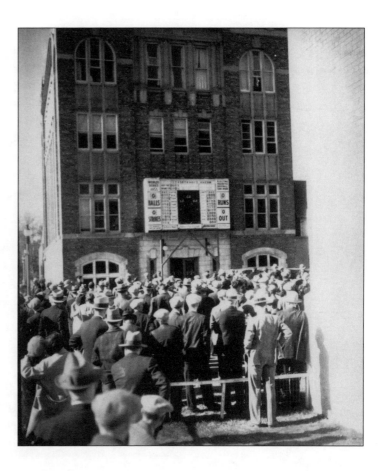

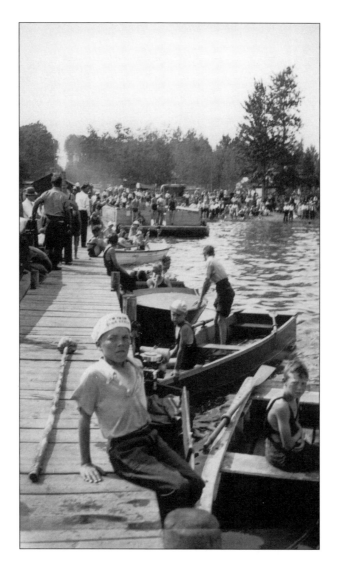

Edmontonians enjoying the Seba Beach Regatta, 1933.
COEA EA-160-656.

Cutting great blocks of ice from the North Saskatchewan River was an industry that began in the early days of the fort. It continued until the widespread availability of electric refrigerators.

Ice harvesting, 1938.
COEA EA-160-318.

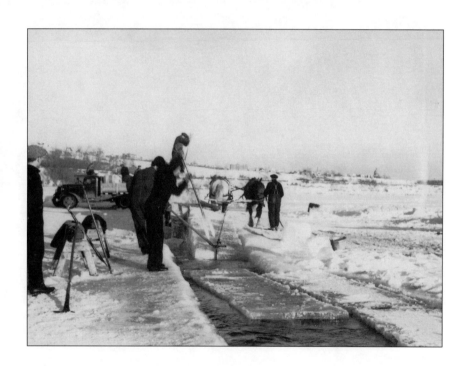

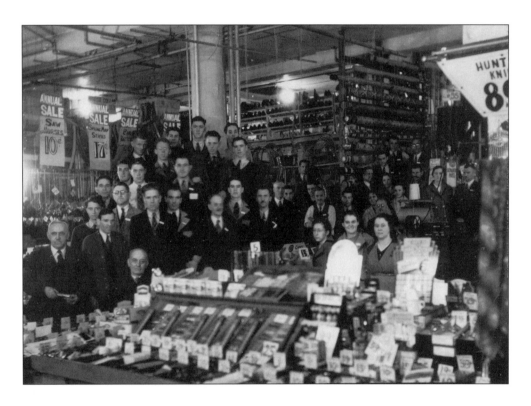

W.W. Arcade sales staff, December, 1935.
COEA EA-160-533.

A CJCA announcer providing parade commentary, 1937.
COEA EA-160-1454.

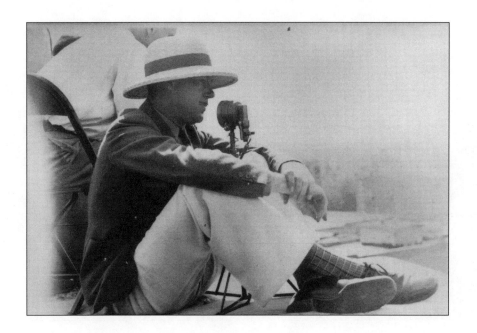

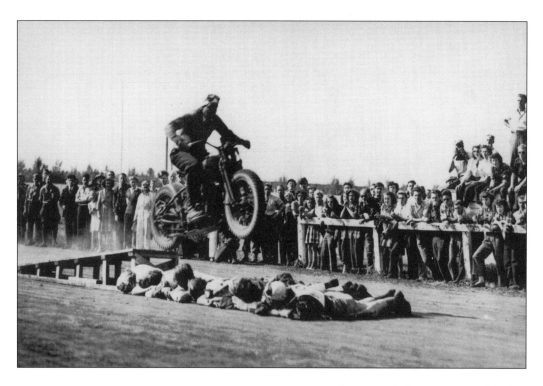

Motorcycle stunt driver, 1938 Exhibition.
COEA EA-160-1401.

Soapbox derby racers on McDougall Hill in 1940.
COEA EA-160-1457.

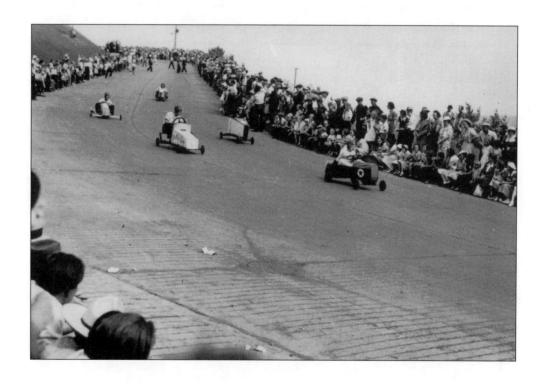

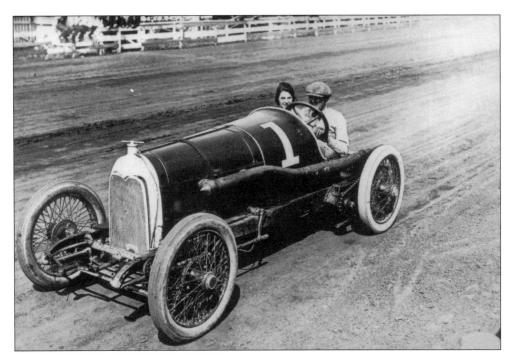

A Maxwell Special on the Exhibition grounds race track.
COEA EA-160-112.

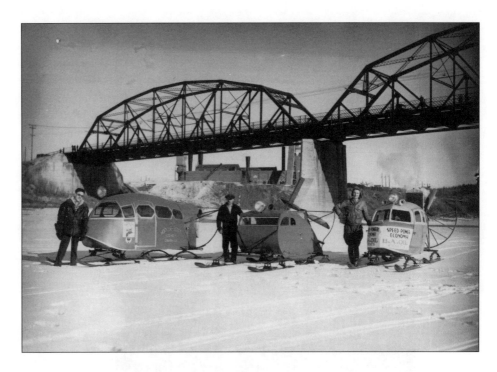

Edmonton-built snowmobiles, January 1937.
COEA EA-160-446.

One of Edmonton's most colourful politicians was "Fighting Joe" Clarke — a man seemingly always engaged in battle, whether in the political chamber, courtroom, sports arena, or the street.

Never afraid of the shady side of the law, Clarke often found himself in trouble, with charges against him ranging from desertion of the RCMP (convicted) to criminal conspiracy (acquitted). Rather than disgracing him, Fighting Joe's legal tangles seemed to enhance a political career in which he acted as a self-avowed "champion of the underdog." He fought for his constituents to the extent of once engaging in fisticuffs with Mayor William McNamara at a council meeting in 1914. Edmontonians liked to see that kind of spirit: between 1912 and 1937, Clarke was elected eight times as alderman and a record five times as mayor.

Despite his number of years in civic politics, one of Joe Clarke's famous accomplishments came about in 1929, a year in which he held no office. Clarke, working for Edmonton as always, used his personal friendship with Prime Minister Mackenzie King to obtain a ninety-nine-year lease of Dominion Government land, at the cost of one dollar per year, for use as an athletic park. The site is now home to the appropriately named Clarke Stadium.

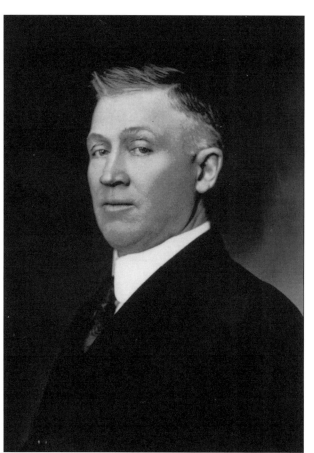

Mayor Joseph Clarke, December 12, 1919.
COEA EA-160-205.

132

Spectators line the street and roof tops during 1938 Exhibition Parade.
COEA EA-160-386.

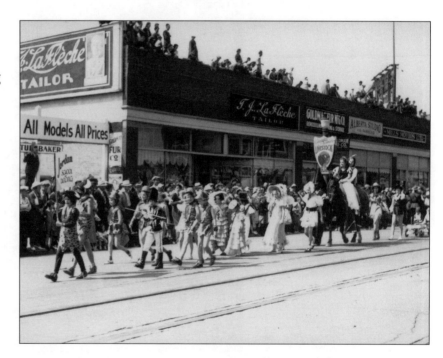

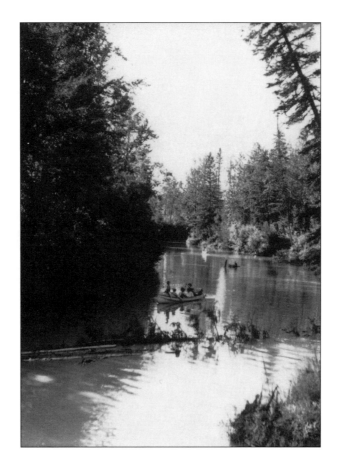

An idyllic summer day, boating on Whitemud Creek, 1938.
COEA EA-160-429.

134

The first telephone call in the Northwest Territories was made in Edmonton, on January 3, 1885, by telegraph operator Alex Taylor. Taylor had ordered the receivers directly from a manufacturer in England after the Bell Telephone Company refused to install service in a centre as small as Edmonton.

Two decades later, Bell changed its mind and offered to purchase Taylor's very profitable system. Edmontonians, nursing a twenty-year-old grudge, said no, voting to buy it themselves, and by January of 1905, the City of Edmonton owned its own phone company.

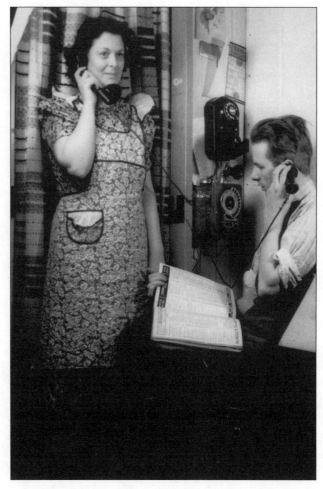

Old and new telephone styles, 1938.
COEA EA-160-612.

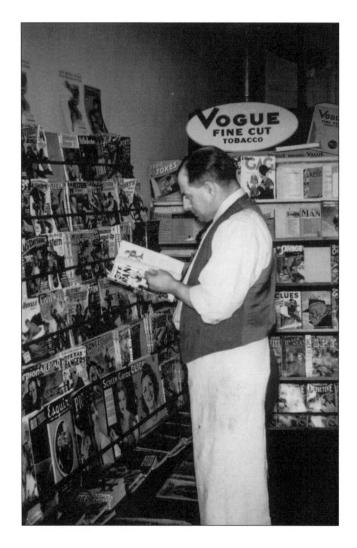

Jack McCullough, proprietor of Jack's News and Confectionery, 1938.
COEA EA-160-1327.

June 2, 1939, King George VI and Queen Elizabeth (now known as the Queen Mother) made Edmonton the last stop on their Canadian tour. It was the social event of the decade, managing, if only briefly, to banish the gloom of the receding depression and imminent war.

Bleachers were erected on both sides of Portage Avenue (re-named "Kingsway" in honour of the visit) so that thousands of eager spectators could enjoy a better view of the Royals.

1939 Royal Visit.
COEA EA-160-883.

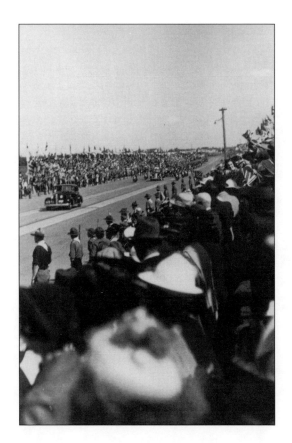

Crowds line Portage Avenue to watch the Royal procession.
COEA EA-29-48.

The idea was born shortly after World War I ended: Edmonton needed a memorial to honour its war dead. It was a sentiment no one could argue, and the fund was seeded with a few hundred dollars that had been willed to the local IODE by a soldier, Private Edgar Franklin Hughes. Thus began one of the longest fund-raising efforts the city would ever know.

It was 1927 before the fund was substantial enough to warrant approaching city council with the idea. It was 1929 before council chose a suitable site, atop Bellamy Hill, and made recommendations regarding cost and design. And it was another seven years of soliciting donations — during the lean years of the Depression — before the Citizens' Cenotaph Committee reached its goal and saw the monument erected.

On August 13, 1936, 5,500 Edmontonians gathered for the unveiling ceremony. They remembered the three thousand men the city lost in the Great War, and listened reverently to Governor General Lord Tweedsmuir's address. His Excellency paid tribute to all World War I veterans when he said that the war had been won "not by the genius of the few, but by the faithfulness of the many." He then struck an ominous note by warning "We may be far from having won peace yet."

Indeed, when the Cenotaph was finally unveiled, the next war was just three short years away. The monument would eventually be rededicated to include the memory of soldiers lost in World War II and the Korean conflict.

Crowds gather at the Edmonton Cenotaph during 1939 Royal Visit.
COEA EA-29-16.

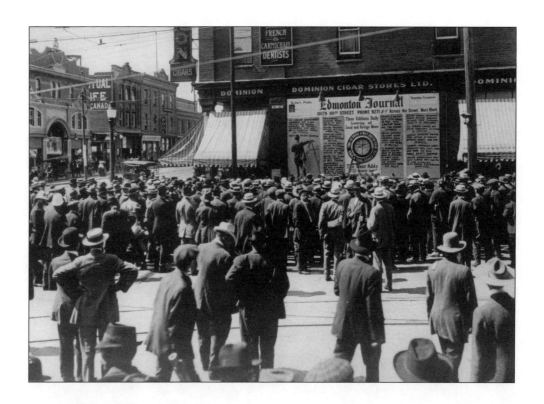

Reading World War I news, August 3, 1914.
COEA EA-122-192.

Edmonton's 51st Battalion went overseas in April of 1916. As it was with most of the battalions recruited in the city, the men of the 51st were separated and reassigned in an effort to strengthen the ranks of units which had suffered losses at the front.

By the end of World War I, Edmonton had sent fourteen battalions, comprised of nearly 16,000 men, into battle.

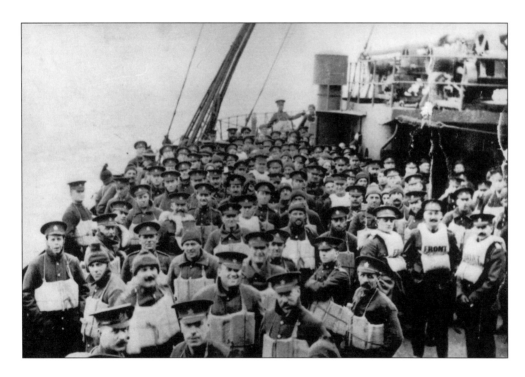

Edmonton's 51st Battalion leaving for Europe.
COEA EA-307-14.

Voluntary enlistment for the 49th Battalion, Edmonton Regiment, began on January 4, 1915. By January 12, the unit had already reached its full strength of one thousand recruits and, under the command of Lieutenant Colonel W.A. Griesbach, began training for overseas service.

The 49th sailed for England four months later, destined to become the only Edmonton battalion to see action as a unit. Regularly reinforced with soldiers from other Edmonton battalions, the 49th saw continuous service and a great deal of battle action until the armistice of 1918.

In World War II, the battalion would march out to battle once more — this time gaining special recognition from King George VI, who honoured them with the name "The Loyal Edmonton Regiment."

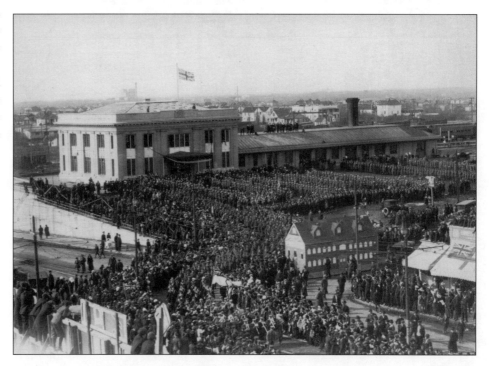

The 49th Battalion returns to Edmonton, March 22, 1919.
COEA EA-63-5.

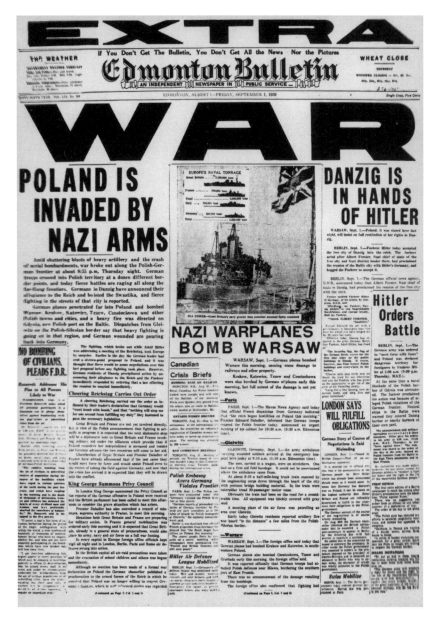

The day that Hitler marched his army into Poland, Canadians began preparing for the inevitable. On September 10, it came, with Prime Minister Mackenzie King's official declaration that our country was at war.

By that time, the conflict had already taken on personal significance for Edmontonians. Only one week earlier, a German U-boat had sunk the ship *Athenia*, whose passenger list included twenty names from Edmonton and northern Alberta.

***Edmonton Bulletin* front page, September 1, 1939.**
COEA EA- 267-138.

142

In 1944 Edmonton "adopted" the Royal Canadian Air Force 418 Squadron, a crack unit comprised of men from the city and surrounding areas.

The adoption agreement meant that citizens of the city provided small comforts to the men — chocolate, chewing gum, and cigarettes were all high on the list of desired items. In return, the fliers, who specialized in night-time intrusion into enemy territory, changed their name to the "City of Edmonton Squadron."

By the end of the war, the City of Edmonton Squadron was the highest scoring in Canada's Air Force, having destroyed 177 enemy aircraft, damaged 103, and shot down nearly eighty V-1 flying bombs.

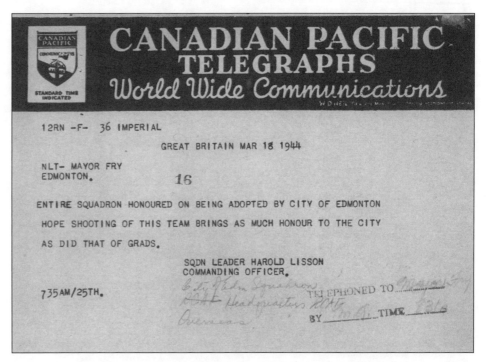

Telegram received from the commanding officer of the 418 Squadron, March, 1944.
COEA RG 11 Cl 115F 11.

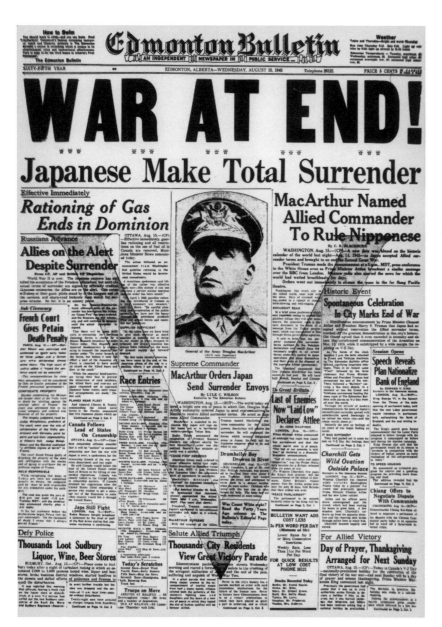

Long before victory was achieved in battle, success of another kind was being enjoyed on the home front. World War II had been devastating in terms of human tragedy, but, ironically, it was also the bitter pill that cured Edmonton's economic ills.

Military spending from south of the border provided the city with a necessary infusion of cash and jobs. Much of the 270 million dollars that the United States spent on construction of the Alaska Highway and Canol pipeline was spent with Edmonton businesses. Building the Namao airport brought in another seven million, and the 20,000-plus American servicemen who had passed through the city by the war's end spent so freely they were actually accused of emptying the stores.

The effect was both immediate and long-lasting: World War II ended the Depression and marked the beginning of four straight decades of prosperity in Edmonton.

Edmonton Bulletin **front page, August 15, 1945.**
COEA EA-267-144.

Flooding in 1940: 90 Street near 119 Avenue.
COEA EA-160-847.

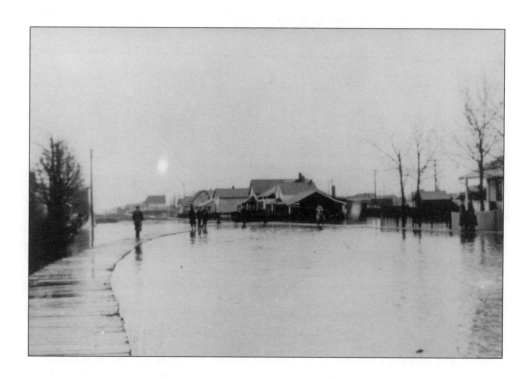

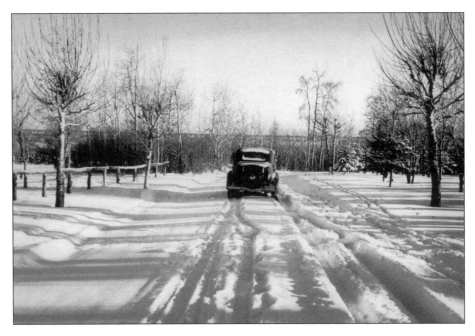

River Road, west of the High Level Bridge, 1942.
COEA EA-160-897.

On November 15 and 16, 1942, Edmonton was blanketed in white during a record-breaking blizzard. Nearly twenty inches of snow fell within the space of a day, clogging roads and rails and effectively paralyzing the city.

Schools closed, streetcars ground to a halt, and workers who found it impossible to plow through the drifts stayed home from their places of business. Deliveries of bread and milk were suspended and, worse, coal trucks could not get through — this at a time when coal was a common heating fuel in many homes.

It was several days before services resumed and life returned to normal.

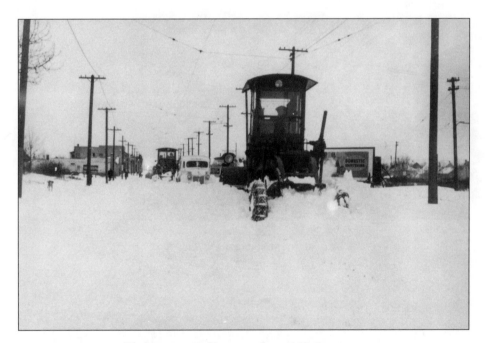

Plows struggling to clear 118 Avenue.
COEA EA-160-851.

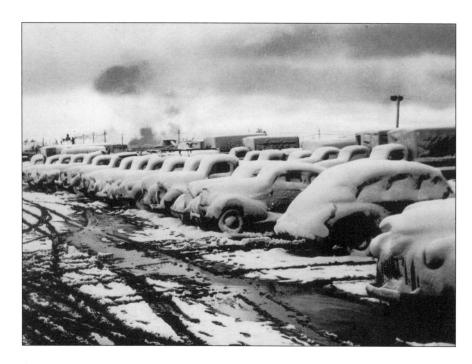

A May snowstorm in 1944.
COEA EA-160-445.

It was a clear, cold, winter's day, and five hundred people waited for hours in a freezing field to witness an event they weren't even convinced would occur. But just before 4 p.m., February 13, 1947, Imperial Oil made good on its promise. Leduc Number One blew into production with a fiery roar, and Alberta's economy would never be the same again.

What the black gold boom meant to Edmonton was a dramatic change in the previously agricultural economic base, and an era of unbridled prosperity and growth. Within ten years, the city's population more than doubled. Within twenty years, it had tripled, and construction of businesses, schools, and housing reflected the trend. Downtown was transformed with office towers, hotels, and shopping complexes; and suburbia swelled to accommodate the huge numbers of new people. Refineries, pipelines, and petrochemical plants appeared almost overnight, and Edmonton celebrated its new role as the oil capital of Canada.

It was an impressive result for a strike that almost never happened. After twenty-three million dollars and 133 dry holes, Imperial Oil had been ready to abandon the hope of ever finding oil in the area. The company was about to cap Leduc Number One when a geologist with a hunch ordered the crew to drill down another five feet. The rest, as they say, is history.

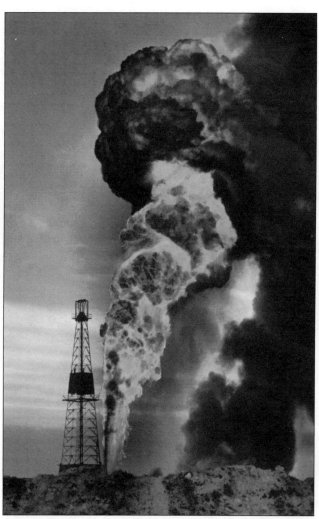

February 13, 1947: Leduc Number One blows in.
COEA EA-10-3164.

149

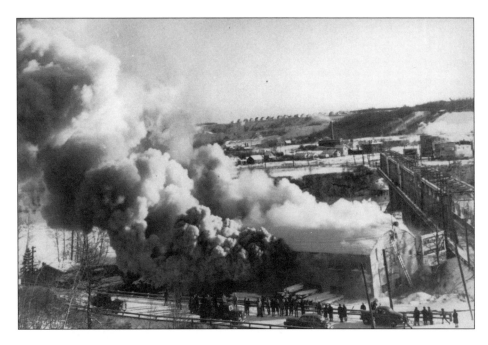

Alberta Motor Boat Company fire, 1948.
COEA EA-160-1026.

Miller Motors body shop fire, 1954.
COEA EA-160-275.

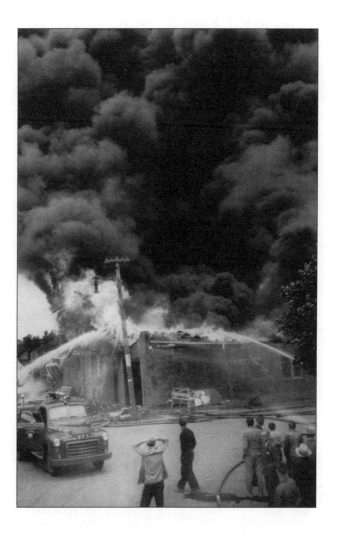

Newlywed couple announcing plan to start a family, 1942.
COEA EA-160-898.

**A Northern Alberta Dairy
Products delivery van, circa 1952.**
COEA EA-295-09.

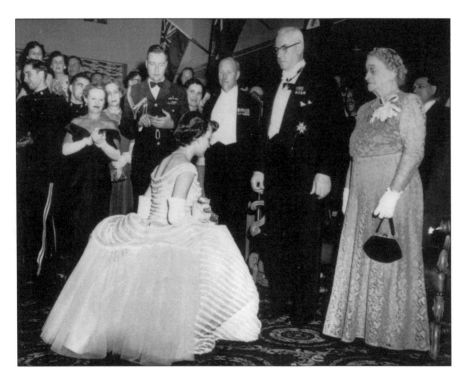

Debutantes Ball at Macdonald Hotel, 1954.
COEA EA-160-289.

In 1948, the Edmonton Flyers picked up where the famous Grads had left off eight years earlier, and gave the city a sports team to celebrate. On May 8 of that year, they defeated the Ottawa Senators to win Edmonton a major team trophy: the Allan Cup.

Tributes poured in, and sixty thousand people — literally half the city — turned out to shower the champions with confetti during a downtown victory parade.

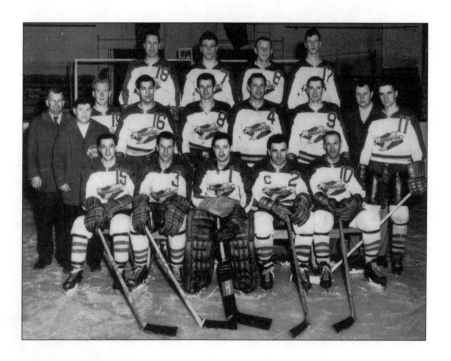

The 1954–55 Edmonton Flyers.
COEA EA-45-1000.

An Edmonton Album

The Edmonton Eskimos were experienced bridesmaids; they had made three trips to the Grey Cup and come home empty handed each time. On November 27, 1954, their luck changed, however. The team overcame their underdog status to win the first of three successive championships, and Edmonton was infected with football fever.

Edmonton Eskimo teammates of 1912.
COEA EA-337-10.

The Edmonton Eskimos: 1954 Grey Cup champions.
COEA EA-20-261.

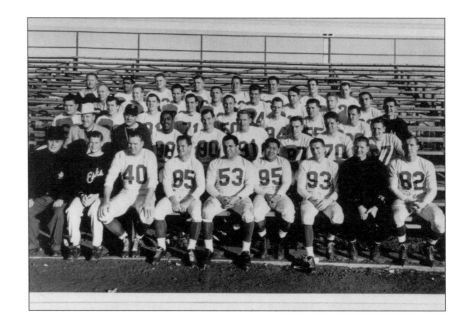

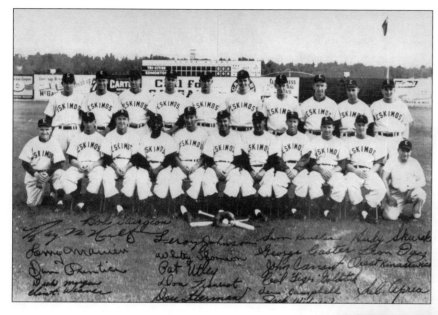

Edmonton Eskimos baseball team, 1953.
COEA EA-45-1071.

I t's a winning tradition: Edmonton has had baseball, hockey, and football teams with the name "Eskimos."

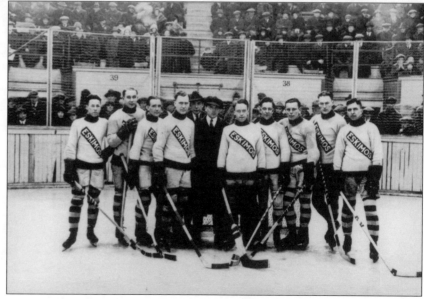

Edmonton Eskimos hockey club, 1920–21.
COEA EA-349-1.

157

At the 1952 Olympics in Oslo, Norway, the Edmonton Waterloo Mercurys became the last Canadian hockey team to bring home the gold. Upon the team's return, the city declared a half-day holiday, and honoured the Mercs with a parade down Jasper Avenue.

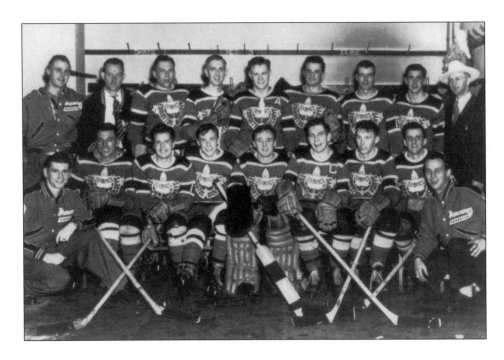

The Edmonton Waterloo Mercurys, 1952.
COEA EA-543-1.

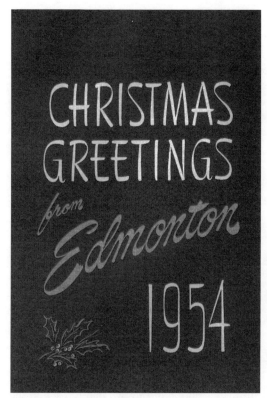

A Christmas card from 1954 illustrates the pride and optimism of the day.
COEA MS 59.2, File 1, A80-133.

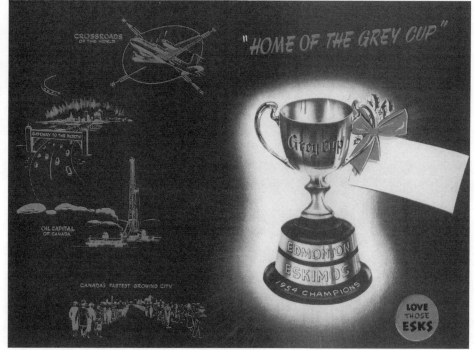

BIBLIOGRAPHY

Apasapowin: Looking Back. Edmonton: The City of Edmonton Archives, 1992.

Cashman, Tony. *More Edmonton Stories*. Edmonton: Institute of Applied Art Ltd., 1958.

Dolphin, Frank J. *The Alberta Legislature: A Celebration*. Edmonton: Plains Publishing Inc., 1987.

Edmonton 100; If They Could See Us Now. Edmonton: The City of Edmonton, 1992.

Edmonton Beneath Our Feet. Edmonton: Edmonton Geological Society, 1993.

Edmonton's Lost Heritage. Edmonton: Edmonton Historical Board, 1982.

Field, Dorothy. *Historical Walking Tours of Downtown Edmonton*. Edmonton: Alberta Community Development, 1995.

Gilpin, John F. *Century of Enterprise*. Edmonton: The Edmonton Chamber of Commerce, 1988.

Gray, James H. *Red Lights on the Prairies*. Toronto: Macmillan of Canada, 1971.

Hatcher, Colin K., and Tom Schwarzkopf. *Edmonton's Electric Transit*. Toronto: Railfare Enterprises Limited, 1983.

Kostek, Michael A. *Looking Back: A Century of Education in Edmonton Public Schools*. Edmonton: M.E. LaZerte Composite High School Press, 1982.

MacGregor, J.G. *Edmonton, A History*. Edmonton: Hurtig Publishers, 1967.

Mair, A.J. *E.P.S., The First 100 Years: A History of the Edmonton Police Service*. Edmonton: Edmonton Police Service, 1992.

Roed, M.A. *A Guide to Geological Features of Edmonton, Alberta*. Ottawa: Geo-Analysis Ltd., 1978.

ARCHIVAL SOURCES

All newspaper references are from the City of Edmonton Archives newspaper clipping files.

PHOTOS

All photos and laser reproductions are courtesy of the City of Edmonton Archives (COEA), with the exception of the two photos used in the introduction, which are from private family collections.